D1190194

# ABANDONED PHILADELPHIA

## THE BIRTHPLACE OF AMERICA

CHRISTOPHER HALL

AMERICA
THROUGH TIME®
ADDING COLOR TO AMERICAN HISTORY

*For Thomas, protector of the Blue Horizon Boxing Ring all the way up until its final days. Wherever you may be now, thank you.*

America Through Time is an imprint of Fonthill Media LLC
www.through-time.com
office@through-time.com

Published by Arcadia Publishing by arrangement with Fonthill Media LLC
For all general information, please contact Arcadia Publishing:
Telephone: 843-853-2070
Fax: 843-853-0044
E-mail: sales@arcadiapublishing.com
For customer service and orders:
Toll-Free 1-888-313-2665

www.arcadiapublishing.com

First published 2021

Copyright © Christopher Hall 2021

ISBN 978-1-63499-316-6

Typeset in Trade Gothic
Printed and bound in England

# PREFACE

P hotography started for me at the age of twelve when I was given a point-and-shoot camera to take photos on a trip overseas with the People to People Student Ambassador Program. I fell in love with the ability to capture and share different moments from my own perspective. The release of Instagram as a platform fueled my desire to take pictures. I began to learn what I could on my own, with much guidance given to me from the tech team at Hedgesville Church in Hedgesville, West Virginia, where my family resided at the time. At the age of fourteen, with the goal to purchase my own DSLR, I started my own business selling prints and offering photoshoot services. It was at the age of sixteen when I realized photography would be what I wanted to do for the rest of my life. Four years later, I am currently studying photography at the Maryland Institute College of Arts in Baltimore, Maryland.

In 2016, when my family moved to North Beach, Maryland, I began to have an interest in photographing abandoned places. Having only lived in the area for a couple of weeks, researching places to shoot led to finding an abandoned mental asylum located about an hour away. Setting out with a friend whom I had just met, we ventured into the abandoned campus. On the first visit, we only explored a small portion of one out of the twenty-two buildings on the property. That was all it took for me. Urban exploring became my passion. The history and story behind these structures drew me in as the smell of asbestos and the sound of chipped lead paint crackling beneath my feet welcomed me to an environment that had been seemingly forgotten about.

I will never forget my first trip to Philadelphia in 2016 to explore abandoned places. The skyline was unlike any other. The people and the culture within the city

were all things I immediately fell in love with. I remember spending hours climbing around the old Delaware Power Station thinking that life could not get any better than this. Going to the power station became a tradition after that day. Every trip into the city would either start or end with the place we referred to as PECO. Trips to Philadelphia to explore abandoned places, see friends, and experience the city of brotherly love have become highlights of my urban explorations.

I dedicate this book to the many people who have influenced, encouraged, and supported my passion for urban exploring. Foremost, I would like to thank my parents for supporting me and my photography interests. I would also like to thank the Farrell family for many childhood memories, which sparked my desire for adventure. Additionally, I am grateful for what I learned from Mr. Quin and Mrs. Radosevic, my high school photography teachers who encouraged me to follow my passion as an artist, which guided me to where I am today.

Furthermore, I am incredibly grateful for all the urban explorers and photographers I have met along the way. There are countless memories with many of you that I will never forget. I would like to give a special thanks specifically to Katie Callander, Justin Curtis, Bart Lentini, and Robin McCoy. Thank you for accompanying me on so many trips into Philadelphia and beyond. Finally, thank you Fonthill Media for this unique opportunity to showcase my work and the many individuals who granted me permission to photograph their abandoned spaces.

# CONTENTS

# 1

# THEATRES

Theatres are one of the types of abandoned spaces that fascinate me the most. Each of them has unique styling, boasting their historical significance within the urban landscape. As cultures shifted away from the city centers, many of these places have become abandoned. While modern movie theaters consist of nothing more than a dark, empty room with some curtains hung against a cinderblock wall, grand theatres of the past were places where renowned architects got the opportunity to truly showcase what they were capable of. The city of Philadelphia has made some progress in resurrecting a few of their larger theatres; however, there are still many that remain in a state of disrepair, despite claims that the buildings are in the process of being renovated.

The Uptown Theatre, which opened February 16, 1929, was an Art Deco-style movie palace designed by architect Louis Magaziner for the Stanley Theatres/ Warner Bros. chain. This grand theater showcased films for the first twenty-nine years. Beginning around 1958, the theatre began hosting live music shows. Many greats performed at the Uptown Theatre, such as Stevie Wonder, Earth, Wind and Fire, James Brown, and The Jackson Five. The Uptown Theatre would continue hosting different performances up until 1972. After 1972, the theatre was used for a variety of purposes until it closed in 2003. In 1982, the Uptown Theatre was added to the Register of Historical Places. There are hopes to restore the building into a community center. While some work has been done, there is still a long way to go before the Uptown Theatre is brought back to its previous glory.

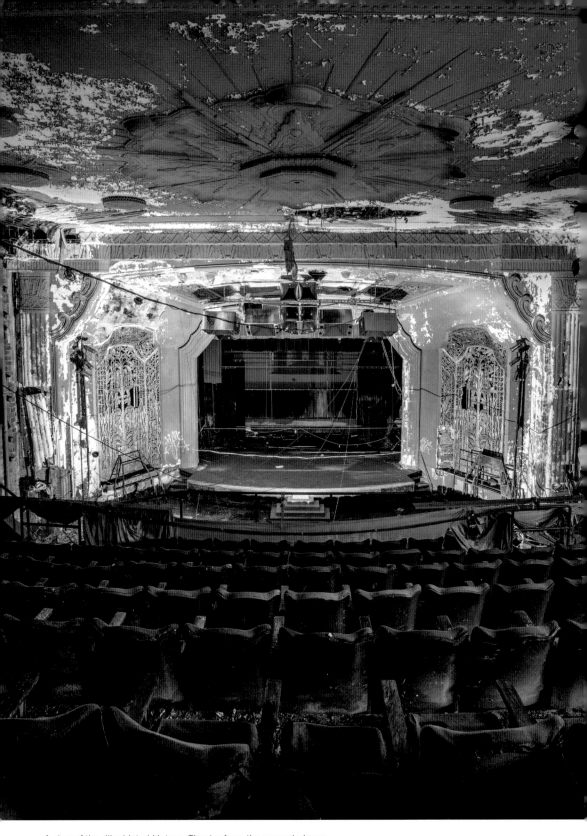

A view of the dilapidated Uptown Theatre from the upper balcony.

During the late 1800s, after an influx of immigrants from eastern Europe arrived in Philadelphia, a commercial district grew along Girard Avenue West and Fifth Street. By March 1891, the 900-seat Girard Avenue Theater, designed by John Bailey McElfatrick, opened to the public. John Bailey McElfatrick was one of the most renowned architects in the nation at the time. The original building's life would be short-lived after an electrical fire broke out behind stage in October 1903, and the fire-retardant asbestos curtain failed to diminish the flames. After the fire, renovations began on the theater. The theater changed ownership midway through the project, and the building reopened in 1919 as a movie theater.

By the 1960s, much of the once-bustling commercial district surrounding the Girard Avenue Theater was demolished and converted into public housing. During this transformation, the Girard Theater closed, and the bottom floor was converted into a supermarket. The theater remained this way for decades. The façade was ripped off the face of the building, and the original grand architecture of the theater remained hidden above the supermarket. The Girard Avenue Theater was demolished between 2019 and 2020. I was lucky enough to see and capture what remained of this theater all the way up until its final days.

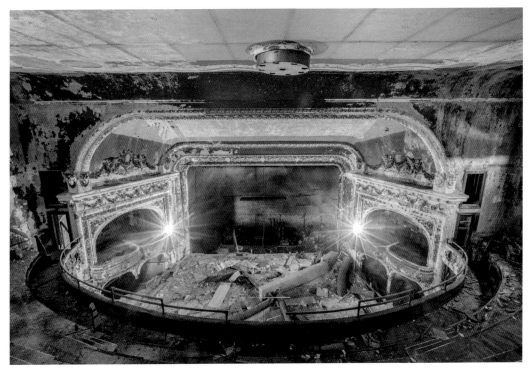

The abandoned Girard Theater that remained hidden above the supermarket.

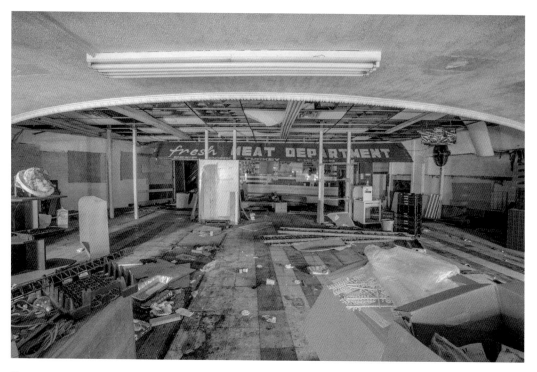

The grocery store that took over the lower half of the theater.

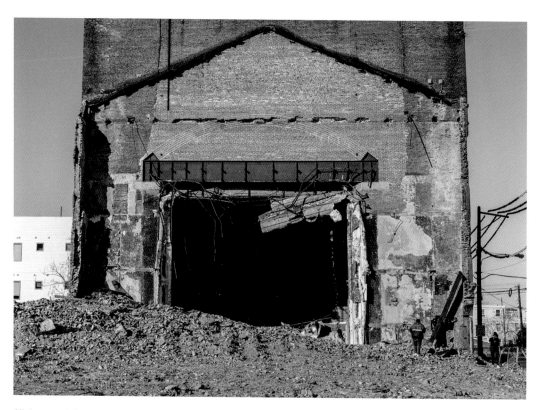

All that was left after demolition crews took a wrecking ball to the over-100-year-old, historic Girard Theater.

Built in 1915, the Tioga Theater had a fifty-eight-year run as a movie house, a music hall, and finally a church. The Tioga became famous for its focus on promoting the jazz scene. Many jazz musicians performed in this theater throughout the 1950s and early '60s. In 1961, the Deliverance Evangelical Church was formed and utilized the building as a center for worship until 1973, when they purchased the Logan Theater.

The Logan Theater opened on January 24, 1924. This 1,894-seat movie theater was designed by the architectural firm of Hoffman and Henon, who had taken part in designing other theaters within the Philadelphia area. In 1973, RKO Stanley Warner sold the theater to the Deliverance Evangelical Church for $350,000. This church group was one of the largest in Philadelphia at the time and often filled the Logan Theater to max capacity. In 1992, the Deliverance Evangelical Church moved to a new location, leaving behind both the Tioga and Logan Theaters to sit abandoned to this day. There have been rumors of plans to save both of these historical buildings, but no visible efforts have started.

The roaring twenties was the time when Philadelphia saw the opening of many theaters across the city. One such theater, although lesser-known, is the Benn, which opened up on September 1, 1923. This theater was operated by the Warner Bros. Circuit Management Corp. and later by RKO Stanley-Warner company. The theater was renovated just six years later in 1929, then closed for good in 1975. Today, the theater remains hidden behind many stores that now occupy the front of the building. Work is being done to preserve the property, but the future of the Benn Theater is still unclear.

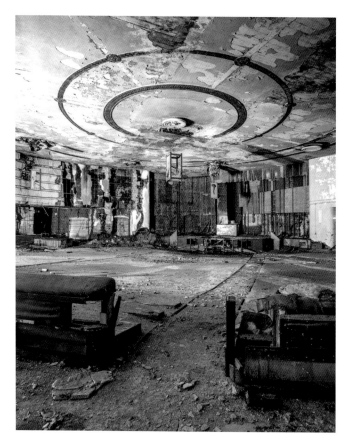

*Left:* The main hall where many jazz concerts would have been held during the early days of Tioga Theater.

*Below:* A few old seats still remain along the outer edges of the main floor.

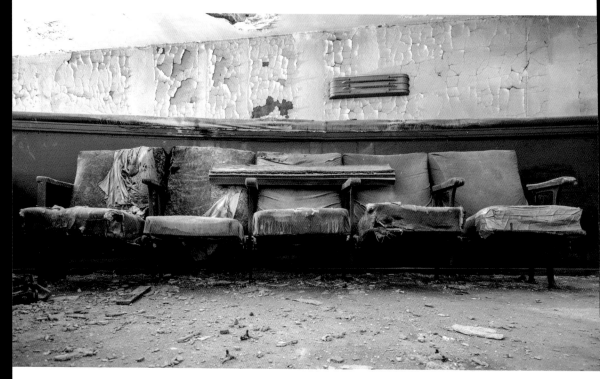

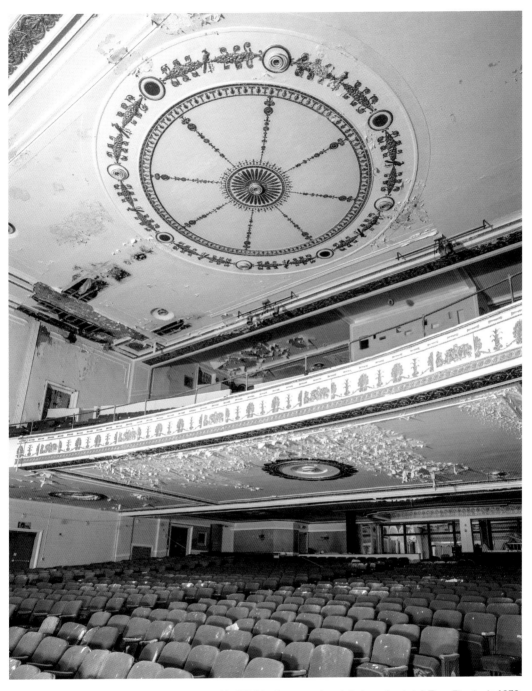

Logan Theater, which was left abandoned in 1992 by the same church that previously left Tioga Theater in 1973.

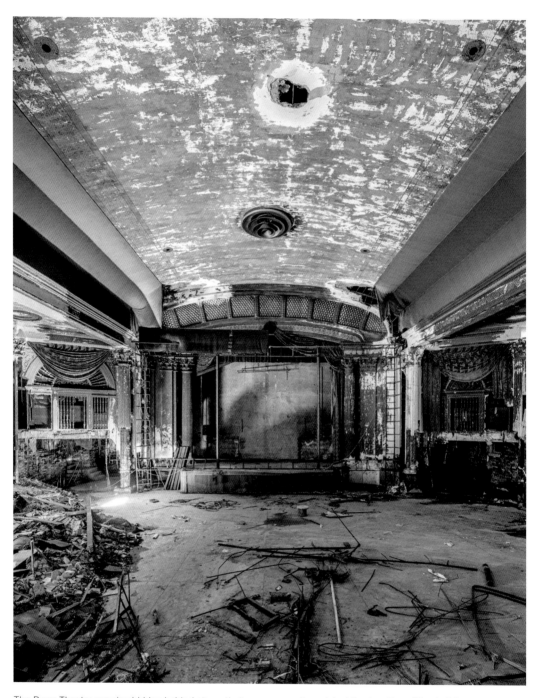

The Benn Theater remains hidden behind stores that now occupy the original front portion of the building.

# 2

# SCHOOLS

Philadelphia is home to a large number of Art Deco-style schools throughout the city landscape. While some are still in use, many have been left standing abandoned for several reasons, such as federal and state budget reductions, making the cost to maintain the aging infrastructures impossible, and a movement of populations into the suburbs. Some of these buildings have been repurposed as charter schools, while others have been converted into apartment complexes. However, today, you can still find countless abandoned schools throughout the city sitting empty with no apparent plans for reuse.

The ornate Art Deco-style design of Philadelphia's school buildings can be largely credited to architect Irwin T. Catharine, who was appointed as the lead architect for Philadelphia schools in 1920. During his time in this position, his efforts resulted in the renovation and construction of over 100 schools across the city. To this day, Catherine is recognized as having designed more buildings than any architect in the city, with nearly all of his schools registered in the National Register of Historic Places. Since these buildings are registered as historical landmarks, developers are unable to demolish the buildings without first gaining city approval.

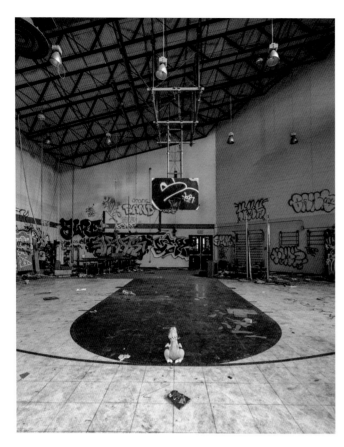

*Left:* A stuffed dinosaur sits at the top of the three-point line inside a gymnasium.

*Below:* Boxes containing hundreds of books lay scattered across an old library.

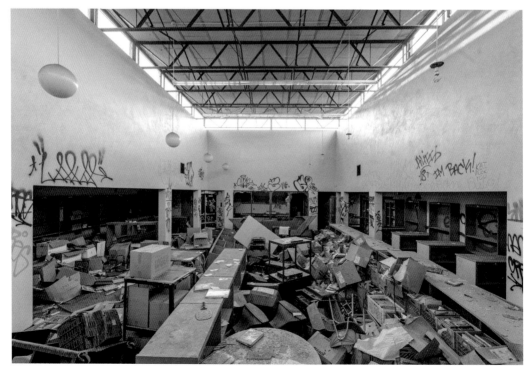

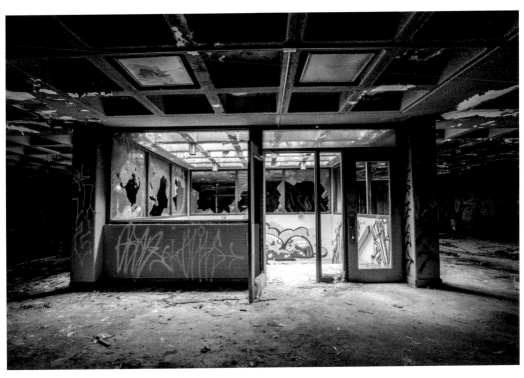

Natural light coming from a skylight above illuminates the dark main hallway of an abandoned school.

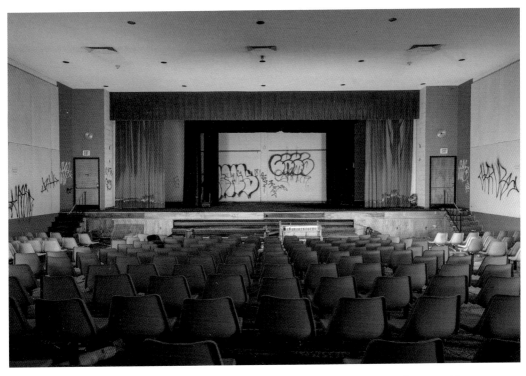

An auditorium full of orange seats that once would have been filled with kids attending assemblies.

Germantown High School, constructed in northwest Philadelphia in 1914, is one of the more notable abandoned schools in Philadelphia due to its massive 355,372-sq. foot size. This school was constructed to meet the demands of the growing population and address the desire to create a centralized complex rather than continuing to maintain the small neighborhood-oriented schools. The school flourished up until the 1960s. During the 1960s, the population began relocating to the suburbs, which drastically changed the economic climate of the area. With a decreased population and decreased budget, the school system lacked the capital to maintain the entire campus and scaled back usage to smaller sections of the building. In 2013, with only about 31 percent of the building still in use as a school, following another round of budget cuts, the Philadelphia public school system made the decision to stop using Germantown High School. Today, it is for sale along with the Irwin Catharine-designed Fulton Elementary School, which is located across the street. The two schools have fallen into disrepair due to vandalism and scrappers wreaking havoc on the historical properties.

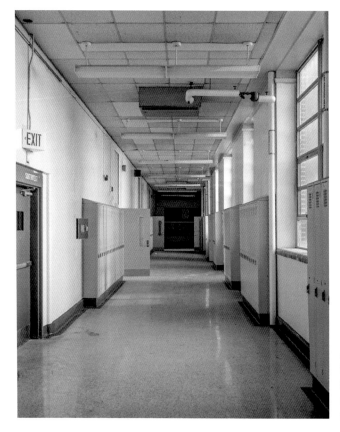

A near spotless hallway inside the abandoned Germantown High School, which has since been a victim of vandalism.

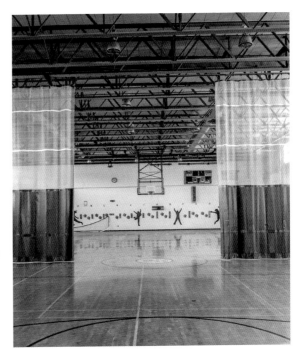

*Right:* The gymnasium where ABA basketball player Mike Sojourner would have played in high school.

*Below:* A decaying portrait of Martin Luther King, Jr., sits at the end of a main hallway.

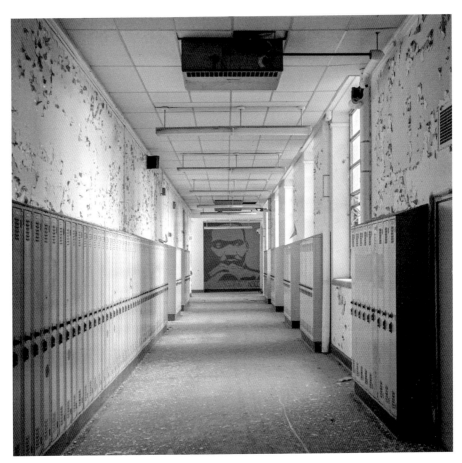

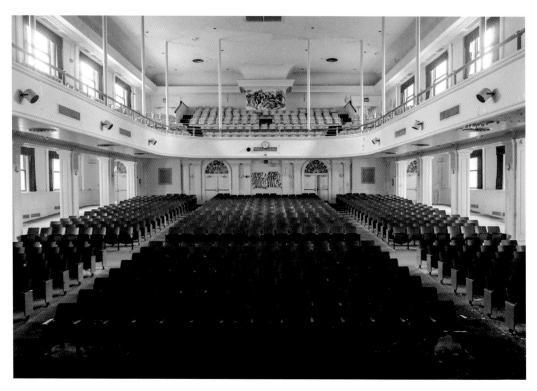

The auditorium of Germantown High School, one of the oldest schools in our country.

Hooks for students to hang their backpacks lay hidden behind this folding chalkboard.

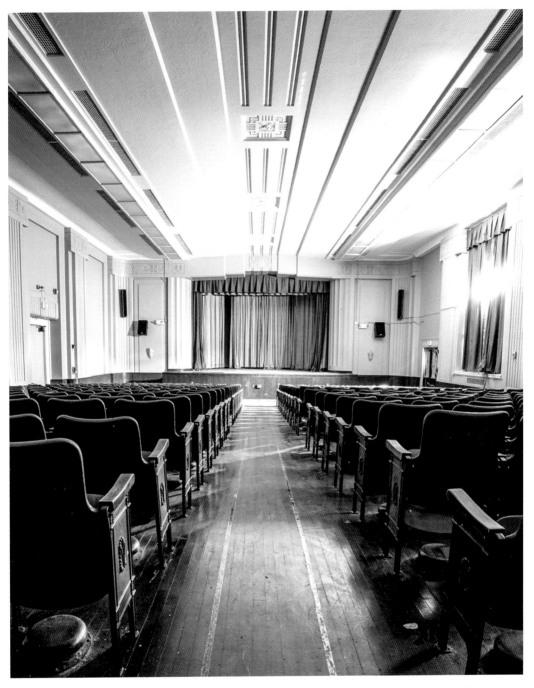

The auditorium of Fulton Elementary School, which also sits abandoned across the street from Germantown High School.

During the same budget crisis that caused the closure of Germantown High School and Fulton Elementary School, countless other schools across the city were closed. To this day, some of these schools have simply been left behind by the city, and very little has been done to maintain any of the properties.

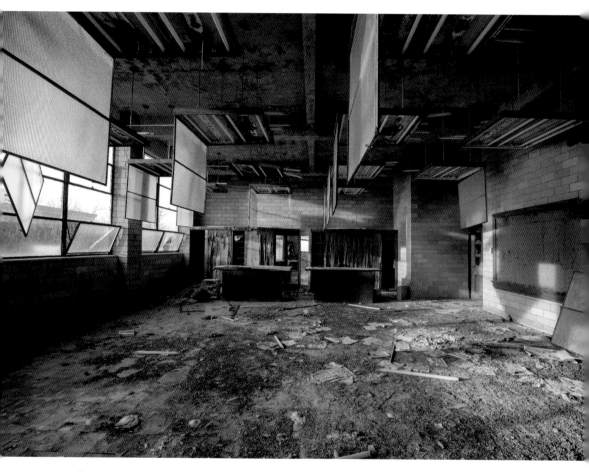

Evening light spills into an old, gutted classroom of school No. 78.

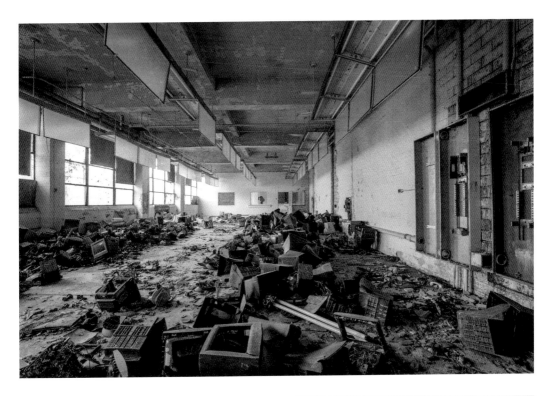

*Above:* A classroom full of scrapped computers.

*Right:* Rusty lockers line the hallways of the school building that has been forgotten about for a very long time.

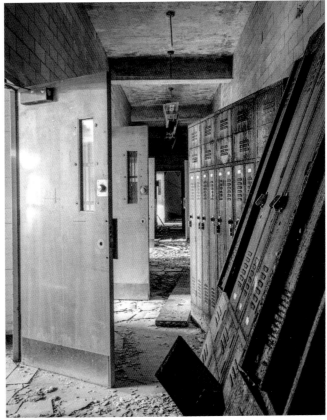

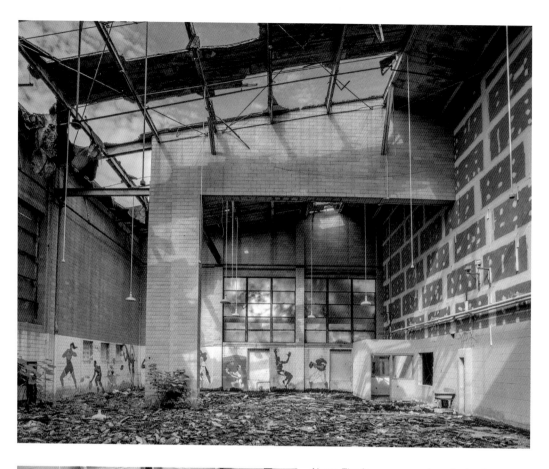

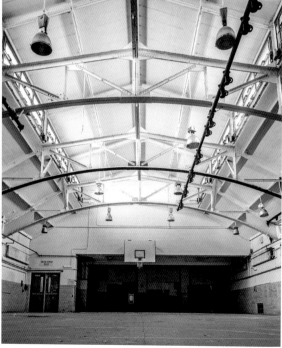

*Above:* The former gymnasium of school No. 78, which nature has begun to reclaim.

*Left:* One of the two almost identical gyms inside of Fitz-Simons High School.

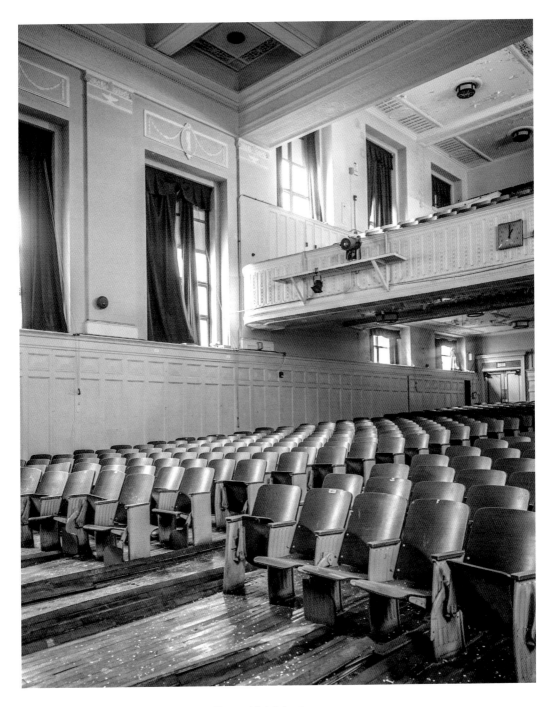

A view of the auditorium inside Fitz-Simons High School.

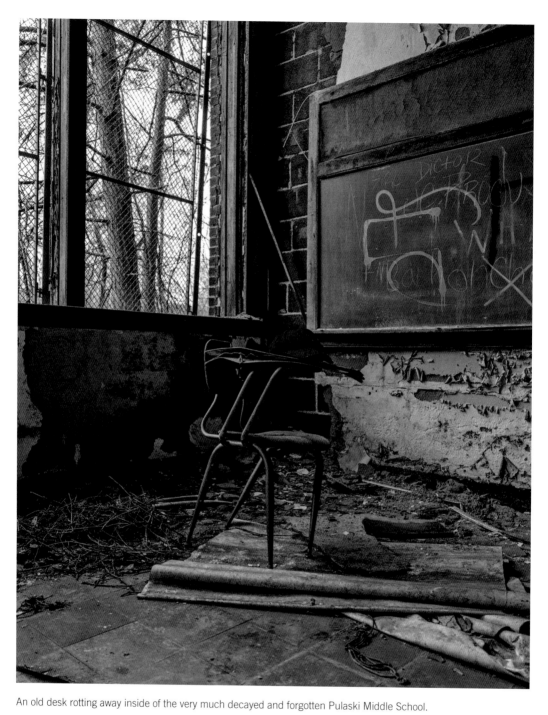

An old desk rotting away inside of the very much decayed and forgotten Pulaski Middle School.

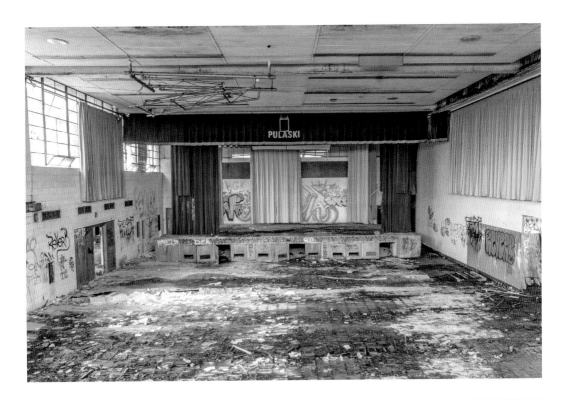

*Above:* Bright yellow curtains line the auditorium of the school.

*Right:* A notable graffiti artist within the community of Philadelphia has a large piece on the wall of the gymnasium.

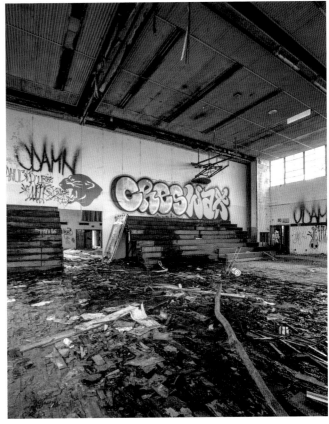

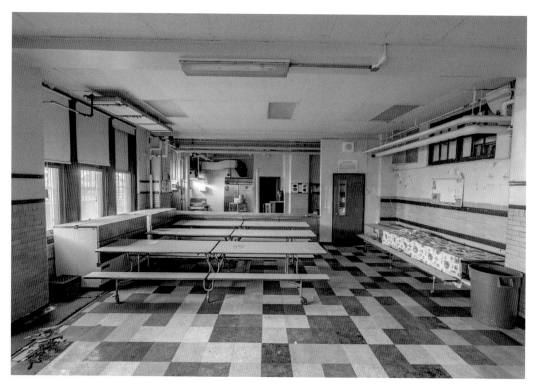

A smaller-sized cafeteria in an abandoned middle school that is currently used for police training.

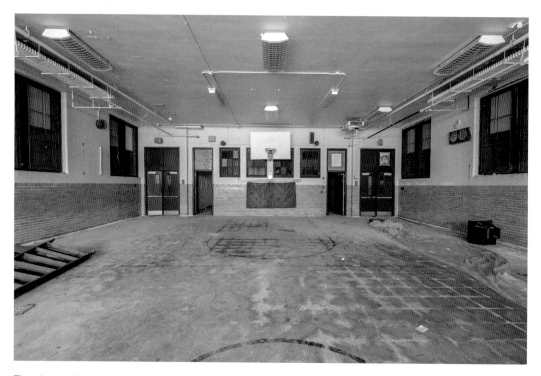

The also small-sized gymnasium of the school featured no stands or anywhere really for seating during a basketball game.

*Right:* The naturally decaying auditorium of the abandoned middle school.

*Below:* A cage surrounded the roof of the now renovated Spring Garden Public School. This space would have been used as their gymnasium and place to play during recess time.

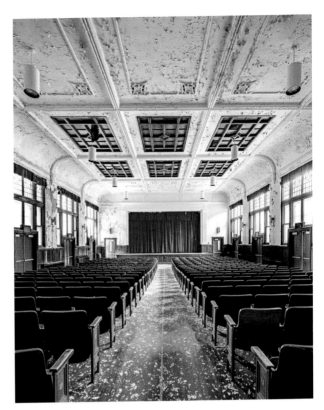

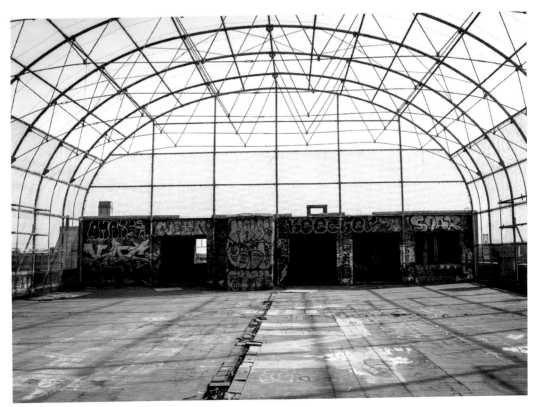

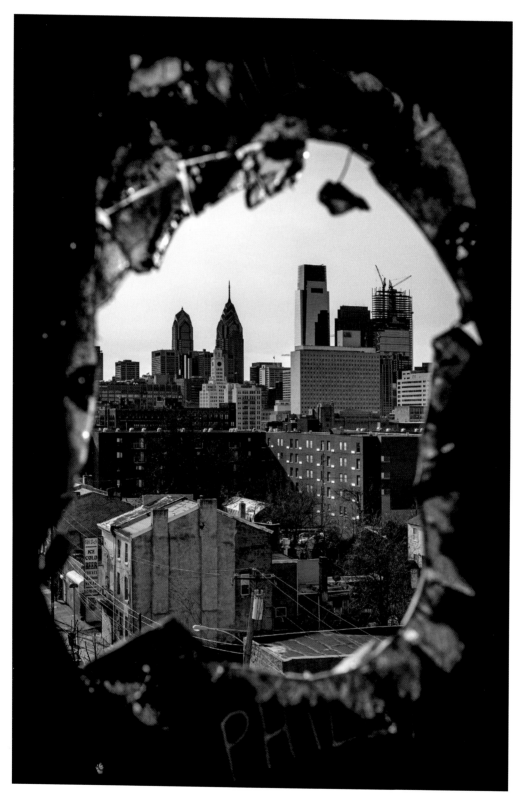

A view of Philadelphia through a broken window inside the Spring Garden Public School.

George Wharton Pepper Middle School opened in 1976 after years of debate over its brutalist design by architects Bower and Fradley. In 1969, the approved design, which originally consisted of a combined high school and middle school, won a silver award from the Philadelphia chapter of the American Institute of Architects. The unique block-style design also gained recognition from *Progressive Architecture* magazine. However, it faced a variety of disapprovals from the Philadelphia Art Commission, which is in charge of reviewing all city-owned construction projects. This resulted in changes being made throughout construction with the most drastic one being the deletion of the originally planned high school portion. The facility remained in use until the budget cuts of 2013.

Today, the property is completely neglected and covered from top to bottom in graffiti art. Often, local kids can be found playing a game of basketball on the courts outside of the school. It is unclear what the future of this school will be. This is truly one of the most unique abandoned high schools I have ever explored. Incidentally, the Communications Technology High School, which was designed by Irwin Catherine, sits abandoned directly next to Pepper Middle School and serves as a stark comparison between two different eras of architectural design.

West Philadelphia High School, built in 1912, was designed by architect Henry DeCoursey Richards. In 2011, after a decline in enrollment, the school was closed. Five years later, the majority of the massive facility that spans the length of an entire city block was turned into an apartment complex called West Philly Lofts. Many of the apartments still contain hints of the original material and infrastructure from the former school.

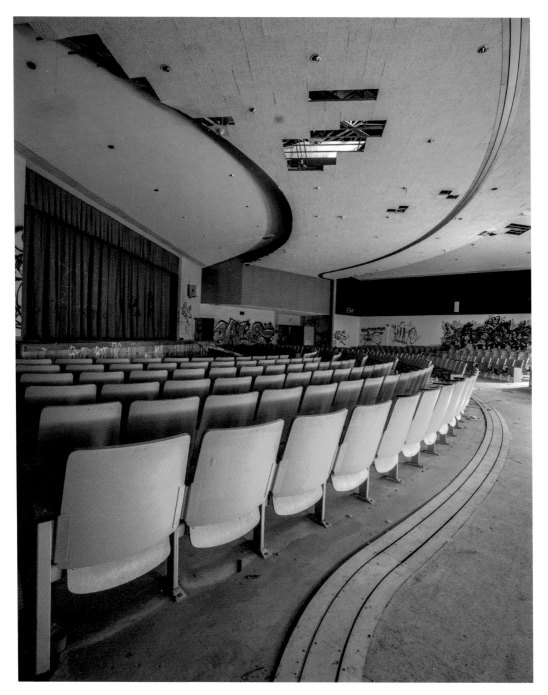

One of the more architecturally unique schools that I have ever explored, the auditorium featured an interesting curvature within its design.

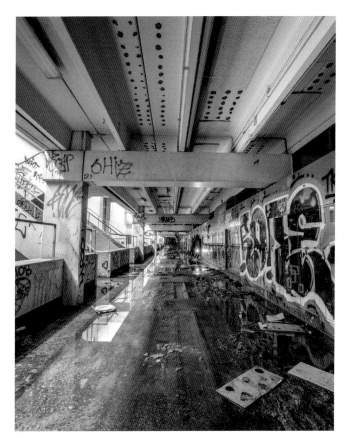

*Right:* Long hallways lined with lockers parallel to each other along the main area inside the school.

*Below:* The gymnasium, along with the rest of the school, has become a place for graffiti artists to come and express themselves with many grand pieces put up throughout the building.

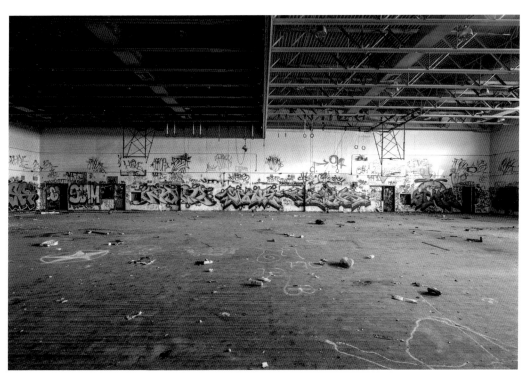

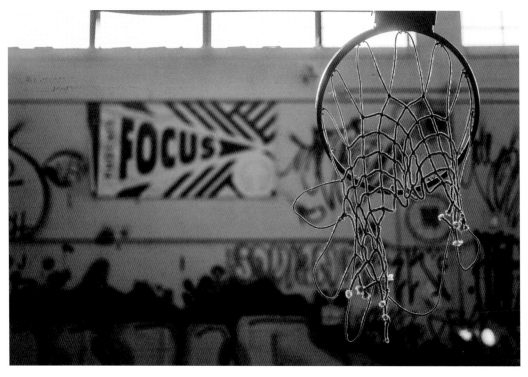

Remnants of the former life Pepper Middle School once had can still be seen through the decay and paint that now covers the interior.

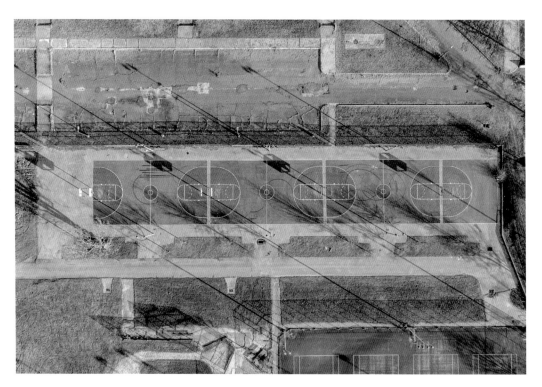

A drone photograph of the many basketball courts that sit in front of the school.

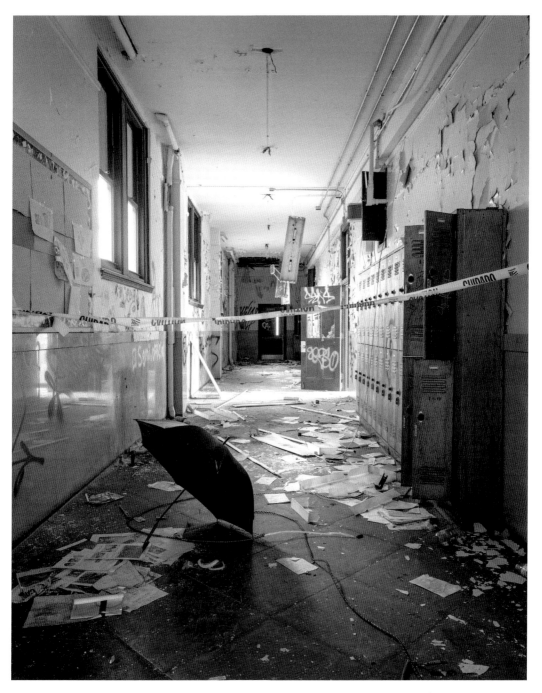

Hallway of the smaller abandoned technical school that sits adjacent to Pepper Middle School.

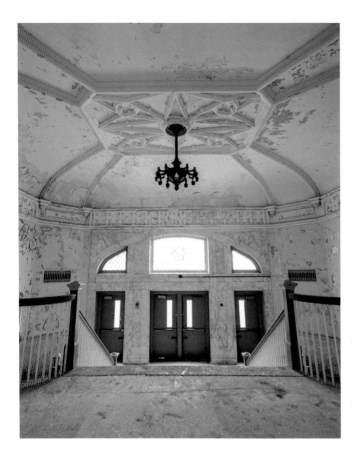

*Left:* One of the grand entrances to the now renovated West Philly High School.

*Below:* The girl's auditorium, which featured plaques of prominent women throughout history.

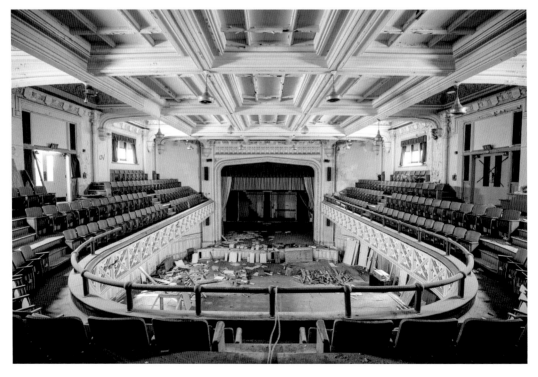

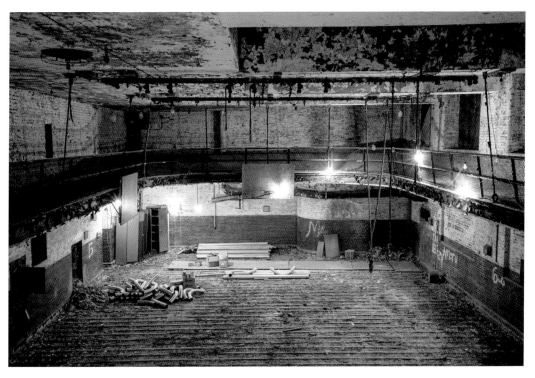

One of the three gymnasiums within the school. This one featured a banked roller rink around its upper floor.

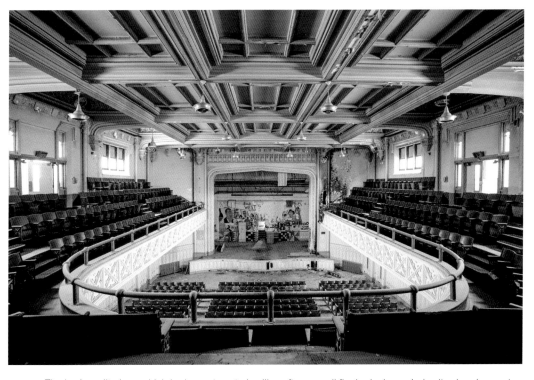

The boy's auditorium, which had a soot-coated ceiling after a small fire broke loose during its abandonment.

# 3

# POWER PLANTS

Philadelphia experienced a growth in wartime industries beginning in 1914 with the start of World War I. In order to support this large-scale effort, more power was needed to fuel the massive plants manufacturing munitions, textiles, and other goods. John T. Windrim, who was known for designing the Schuylkill and Chester power plants in Philadelphia, was hired to design the Delaware power station in what is now known as Fishtown. The Delaware power station was designed using the Beaux-Arts style in order to create what he envisioned as a monument to electricity. The power station's first of six planned turbines was ignited in October 1920. By 1924, all six turbines were running at full power, burning 325 tons of coal per hour.

Throughout the power station's lifespan, changes were made in order to increase the power and efficiency of the plant which included the construction of two additional turbines. By 2004, the turbine units were retired, and the power station was closed. It sat neglected for many years until around 2018 after developers introduced a plan to convert the property into an event center with office space and restaurants. Today, construction is well underway on the massive structure.

Not far from Delaware power station lies another dormant power plant called Southwark Generating Station. This facility was constructed in 1941 to support the increased power demands of the manufacturing efforts for World War II. Architect Paul Philippe Cret designed Southwark following in Windrim's efforts by incorporating the tradition of the Beaux-Arts influence. The power plant operated from the mid-1900s into the early 2000s until Exelon acquired the property and closed the facility.

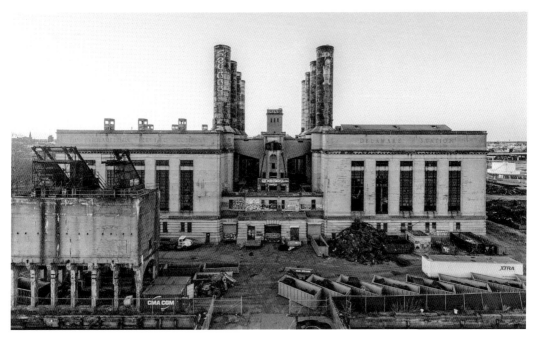

Delaware power station during the beginning stages of its restoration process.

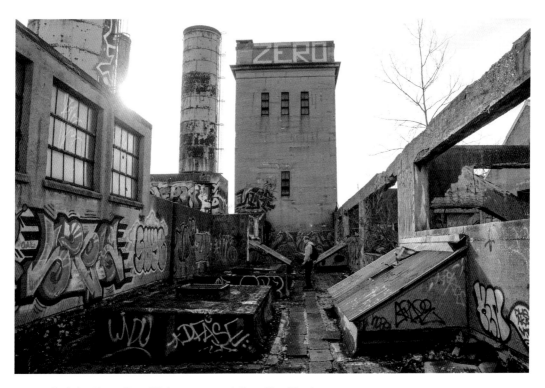

Exploring the rooftop of Delaware power station with a friend.

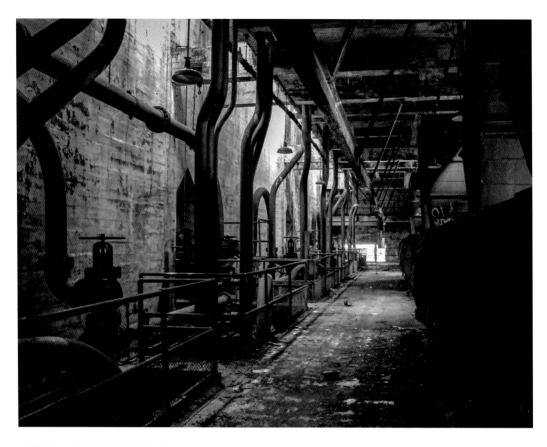

*Above:* One of the many hallways lined with different pipes.

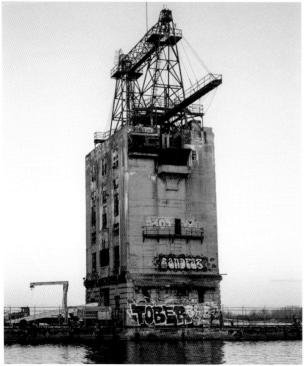

*Left:* The coal tower of Delaware power station sitting along the water.

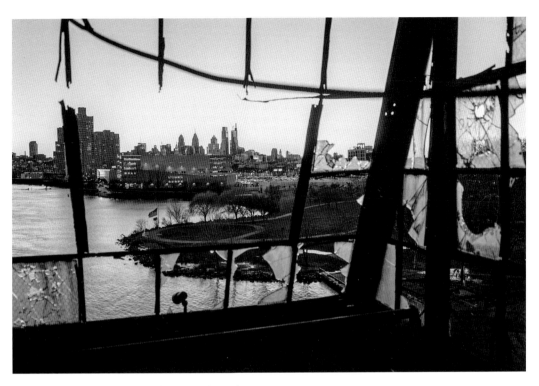

Overlooking Philadelphia from atop the coal tower.

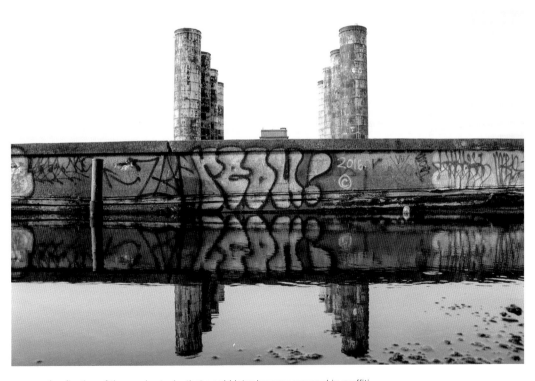

A reflection of the smokestacks that would later become covered in graffiti.

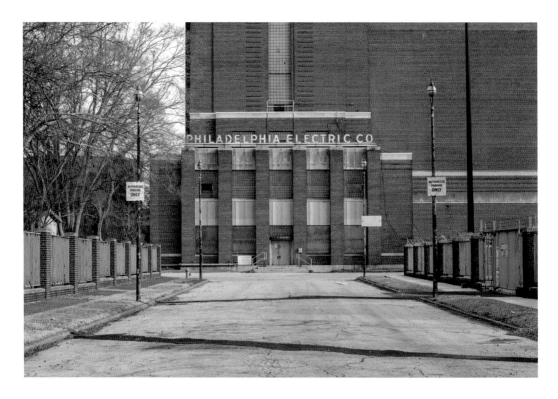

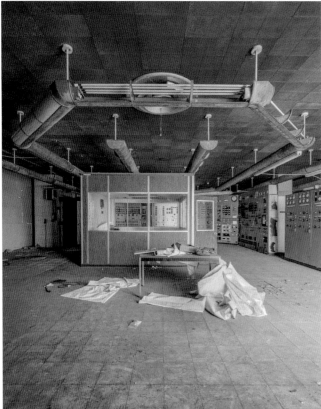

*Above:* The main entrance to Southwark Generating Station.

*Left:* A very dated main control room of the power plant.

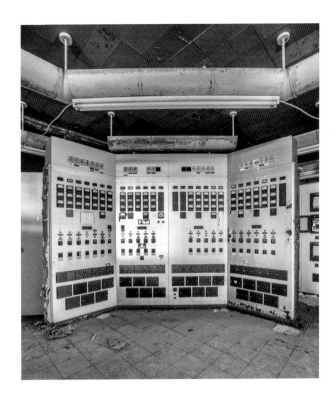

*Right:* One of the control panels at Southwark Generating Station.

*Below:* The main turbine hall of Southwark Generating Station.

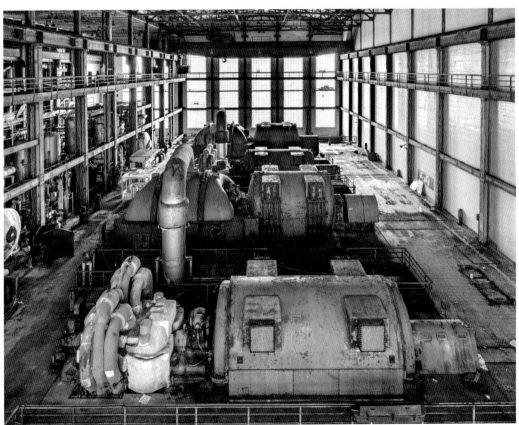

Once housing the world's largest Westinghouse turbo generator, the Richmond power station opened in 1925 to continue to compensate for the increased need for power within Philadelphia. The power station, designed by John T. Windrim, showcased similar neoclassical architecture to the station in Delaware, which he also designed. This facility featured a truly remarkable grand turbine hall with a ceiling 130 feet above the floor. The power plant remained operational until 1985. Today, the property around the original structure is still in use and houses a small office space. The main building has succumbed to the demise of scrappers looking to cash in on the metal and wiring left behind. The Richmond power station remains as a pinnacle example of design and engineering from the early 1900s. As a result of its unique architecture, the facility has been utilized as a film set for a variety of movies and television shows.

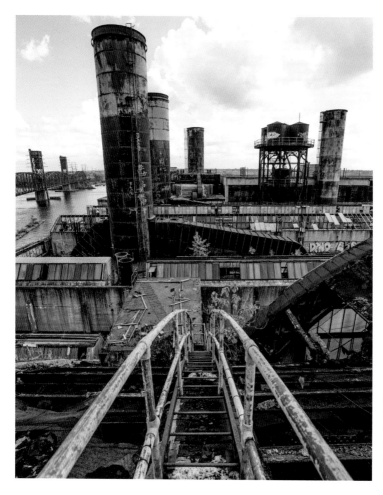

A view of the industrial playground that lies atop of Richmond power station.

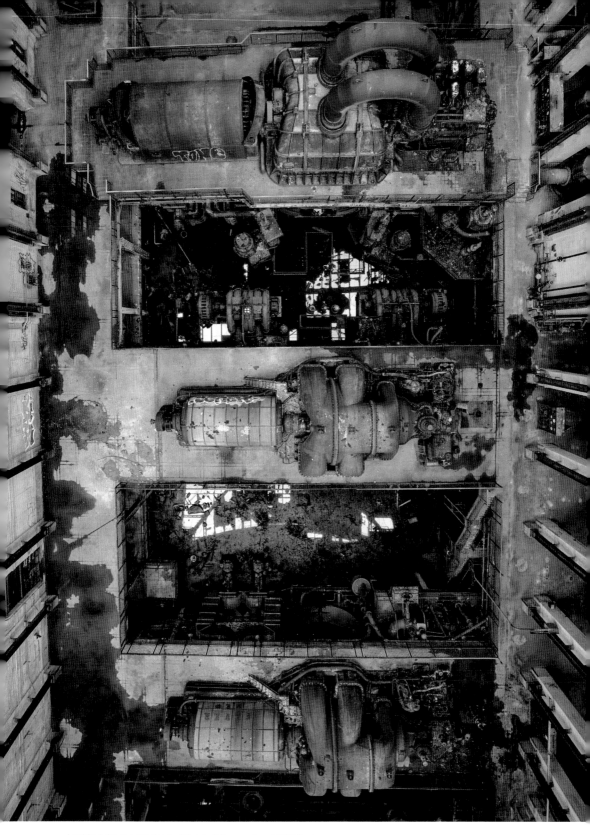

Looking down onto the turbine hall from around 130 feet up.

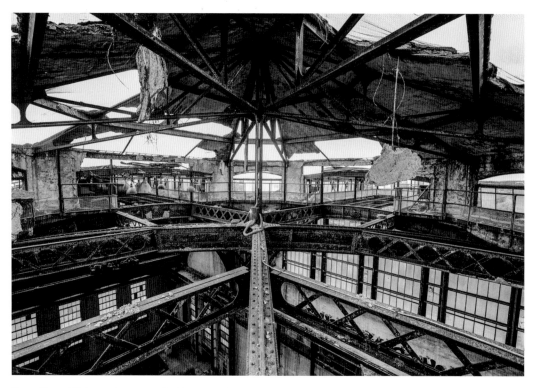

The ceiling of Richmond power station has been slowly deteriorating over the years.

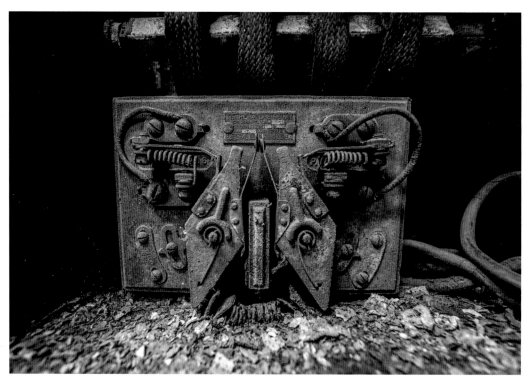

A face found on an old temperature relay.

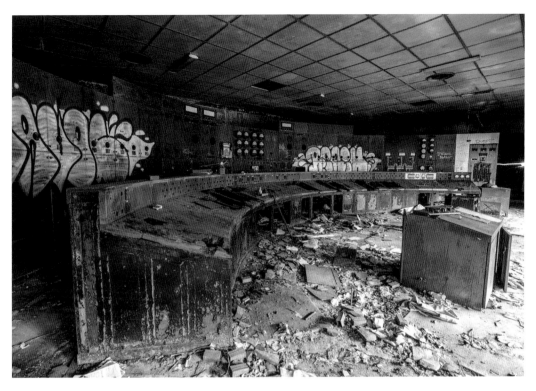

What is left of the main control room.

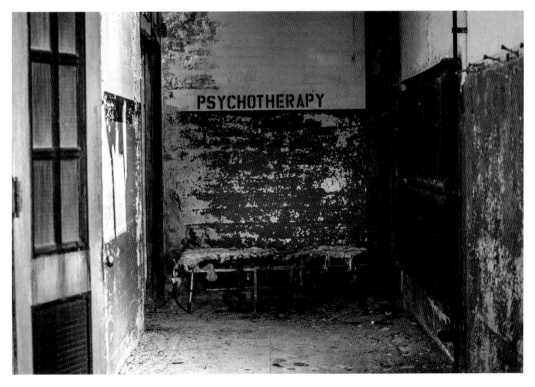

Remains from different movie and television show sets can be found throughout the building.

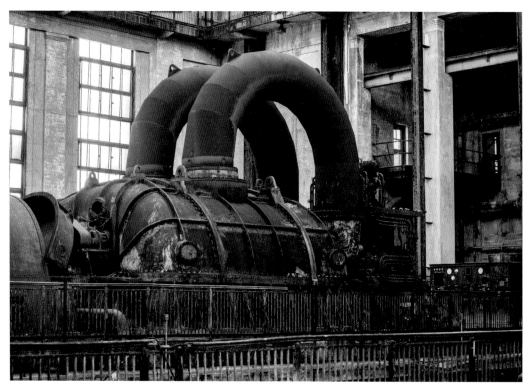

One of the four massive turbines within Richmond power station.

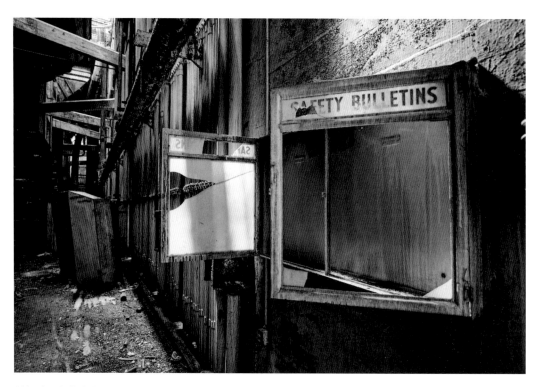

Old safety bulletin boards found against the wall right outside of the main hall.

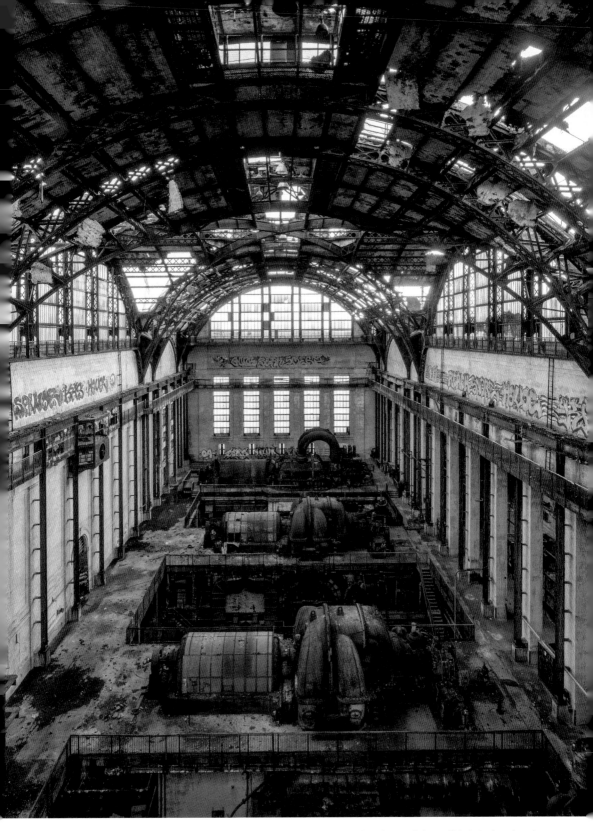

An early sunrise illuminates one of the largest open rooms ever designed—a truly incredible feat of engineering.

# 4

# CHURCHES

The city of Philadelphia is home to around 830 religious structures. Over the past two decades, a plethora of these places were abandoned due to shrinking congregations, which caused a shortage in the funding needed to maintain these structures. Since these places often hold great sentimental value, the local communities have been reluctant to allow developers the opportunity to tear them down for redevelopment. Over the years, I have had the opportunity to photograph many abandoned places of worship. It is amazing to see the immense amount of detail and craftsmanship that goes into some of these places. At the same time, it is often unfortunate to see what some of these places of worship have turned into since the time of their abandonment.

One example that comes to mind is an abandoned cathedral in Kensington that I once explored. Locals described this abandoned building as a place where illicit drug activity was rampant. A sense of curiosity about this horrific place got the best of me, and I eventually plucked up the courage to go see it for myself.

I cilmbed through an open window and was greeted with hundreds of used needles spread across the floor. Carefully making sure not to step on anything, I began to set up my tripod to start photographing the space. Within minutes of doing so, dirt bikes and four-wheelers pulled around the church with loud music that echoed throughout the large, empty building. They started shooting BB guns through the windows, and the little pellets ricocheted everywhere. I quickly packed up and hurried toward a back exit. After leaving the building, I walked around to the front to get into my car, and I could see the people who shot the BB guns into the windows. They were boarding up the window I had originally come through to access the church. This was probably one of the wildest experiences I have ever had while exploring in Philadelphia.

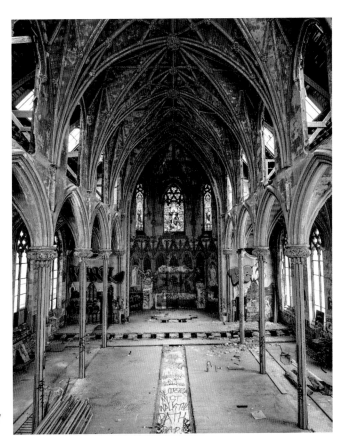

*Right:* The historic Church of Assumption, built in 1848.

*Below:* A once-grand cathedral in Kensington, now just an empty building laid to waste.

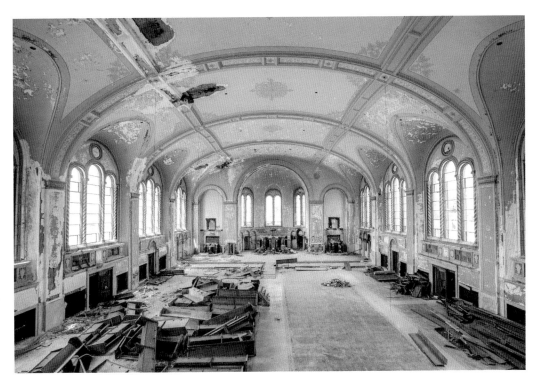

I have had the opportunity to explore many of the abandoned religious build-
ings across Philadelphia. Each of these places sits in a state of decay waiting for
developers and local communities to decide what to do with the architecturally
significant structures. The following series of photos highlights the sheer volume
of neglected churches within the city of Philadelphia and the potential so many of
these buildings hold for future development.

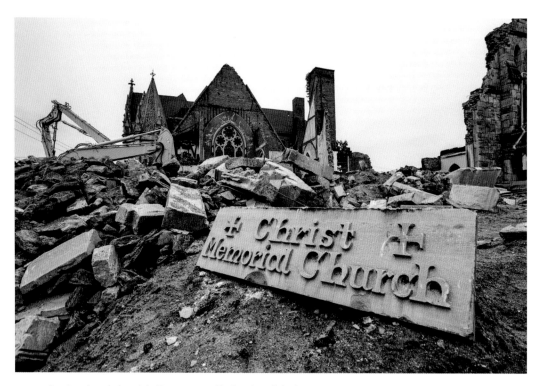

An abandoned church in the process of being demolished.

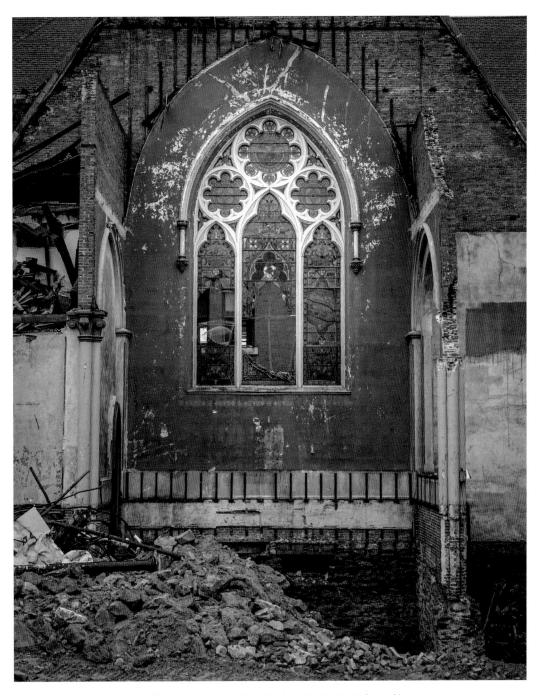

A stained-glass window that would later join the pile of rubble that lay in front of it.

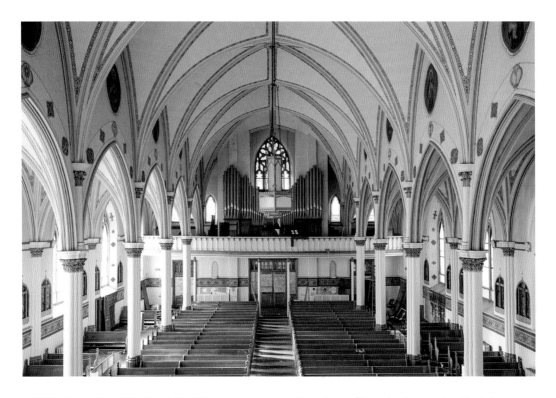

*Above:* Another ornate cathedral that has been boarded up and forgotten about.

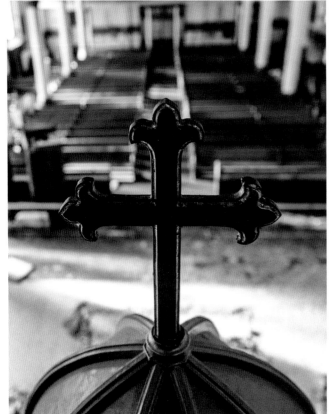

*Left:* The cross remains standing above the poorly desecrated altar.

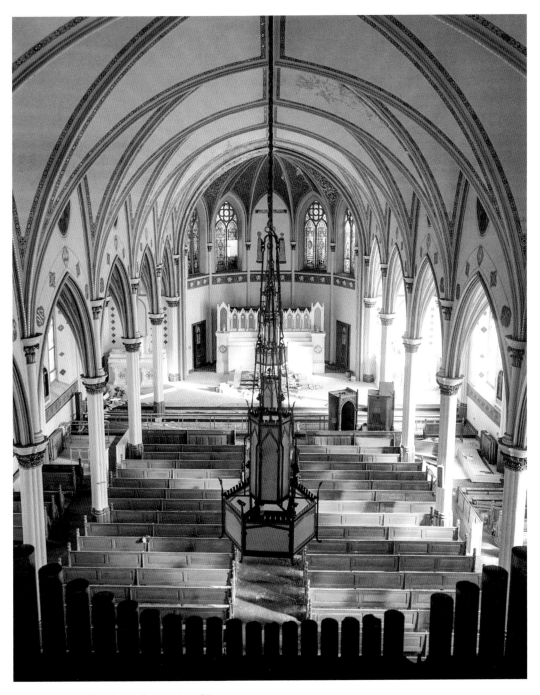

A view of the church from on top of the organ.

A small Catholic school connected to the church also sits abandoned.

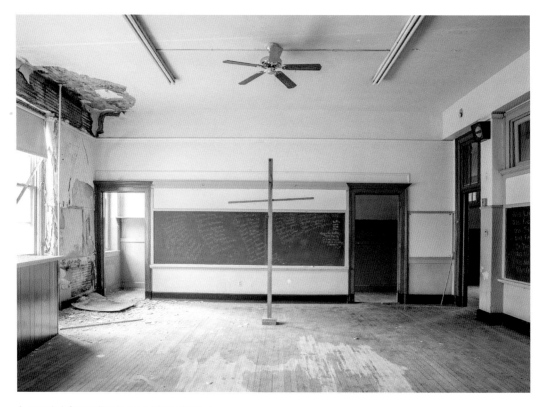

A cross is left standing in the middle of this classroom.

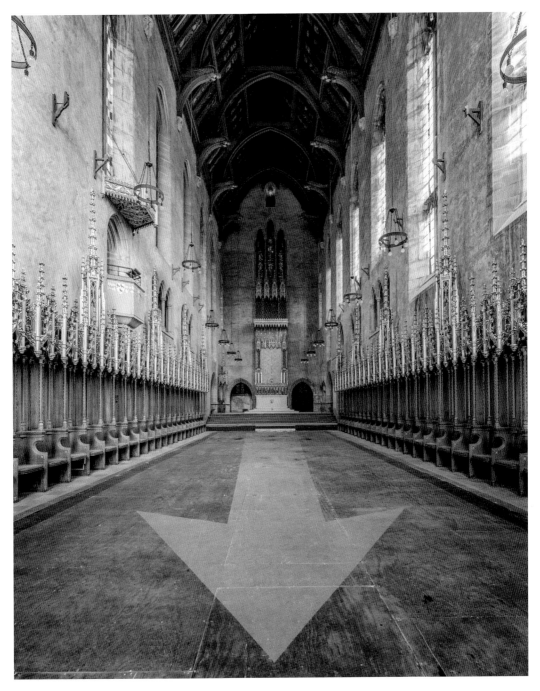

St. Andrew's is another disused chapel connected to a currently active school.

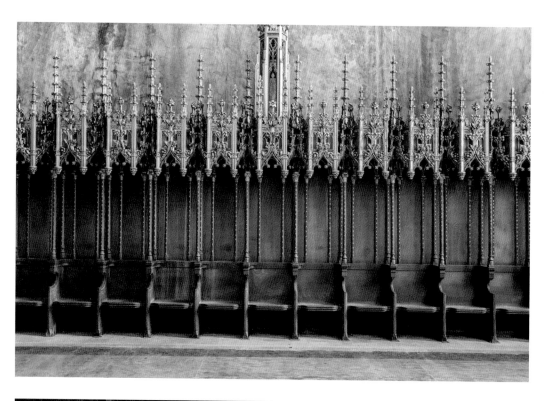

*Above:* Seats line the walls of the main hall.

*Left:* Inside a small historic chapel rotting away.

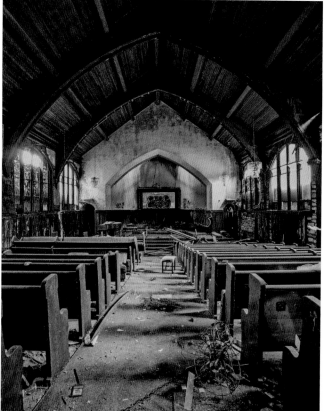

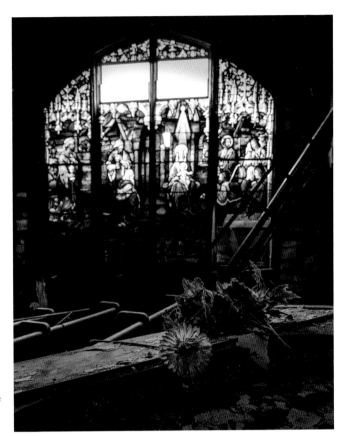

*Right:* The stained glass has remained in decent shape over the years, as well as the fake flowers and the piano that continues to sit and collect dust.

*Below:* On the second floor of the very structurally unstable church is a small stage.

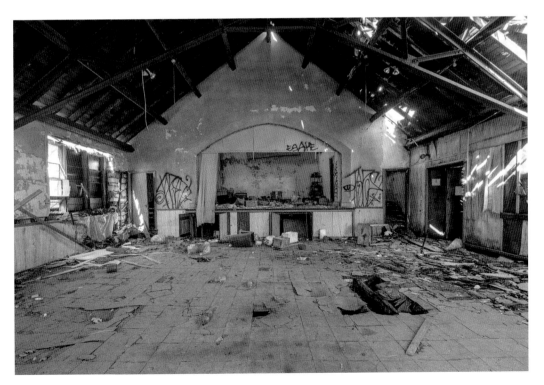

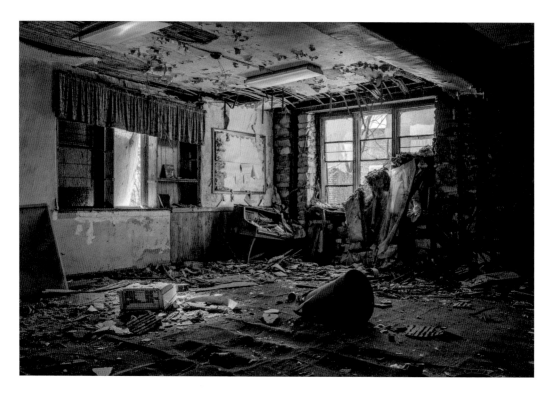

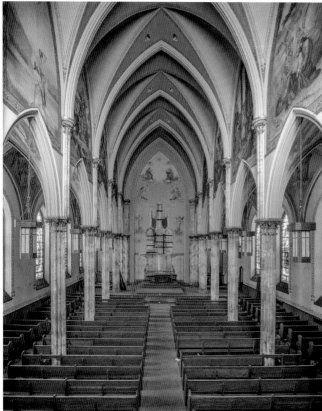

*Above:* Back on the first floor, underneath the stage, is what appears to be a Sunday school classroom.

*Left:* One of my absolute favorite abandoned churches in Philadelphia that unfortunately faces the constant threat of demolition.

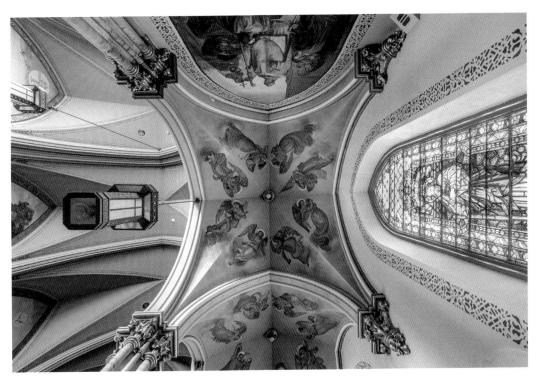

Angels line either side of the ceiling inside the cathedral.

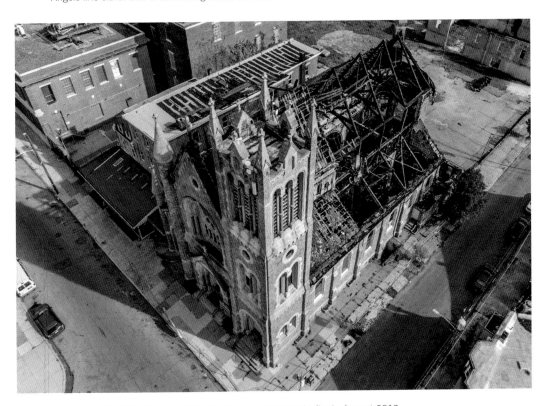

A drone photo of the Greater Bible Way Temple that caught fire in August 2019.

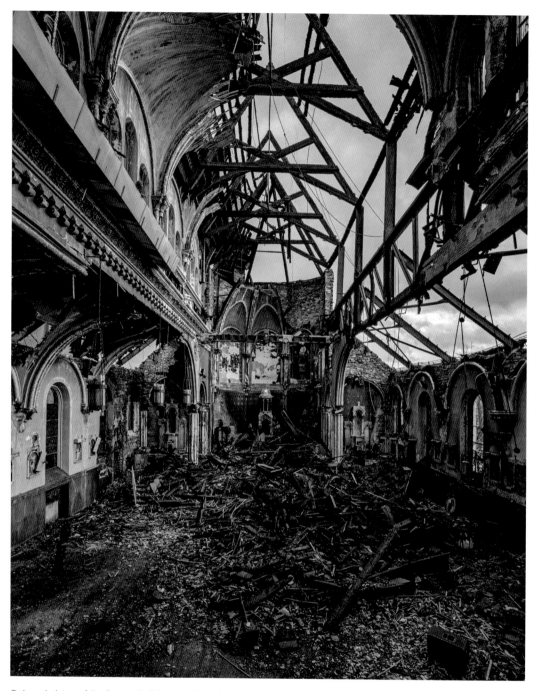

Only a skeleton of the former building remained before it was later demolished a year later.

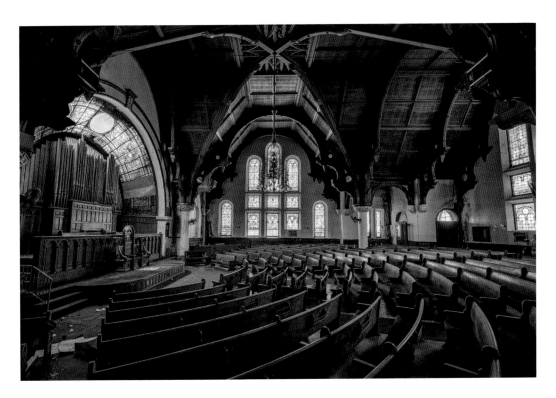

*Above:* Stained glass
compliments the ornate wood
architecture of this abandoned
church.

*Right:* An abandoned church
sitting in front of a large
cemetery.

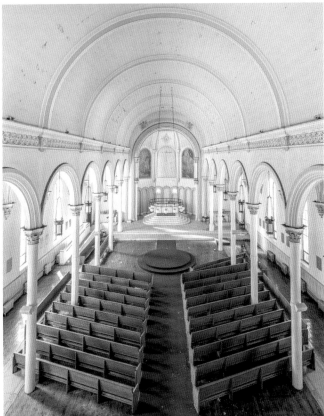

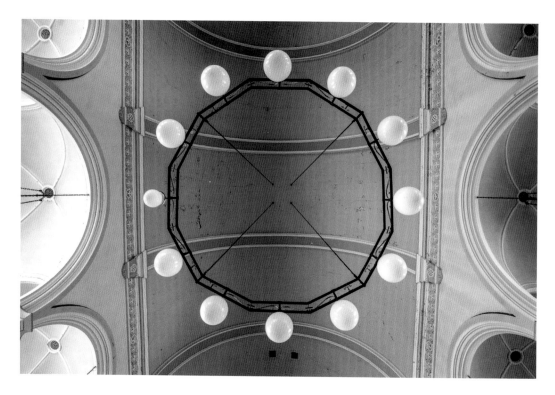

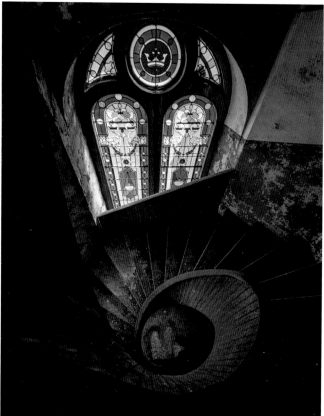

*Above:* A look up of a round chandelier that hangs towards the front of the cathedral.

*Left:* A spiral staircase leads up to the organ.

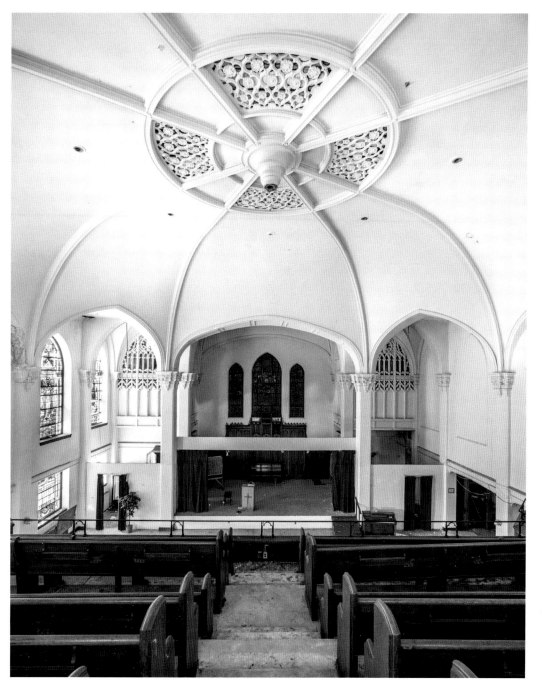

A historic abandoned church that has been left to decay after the congregation built a new building across the street.

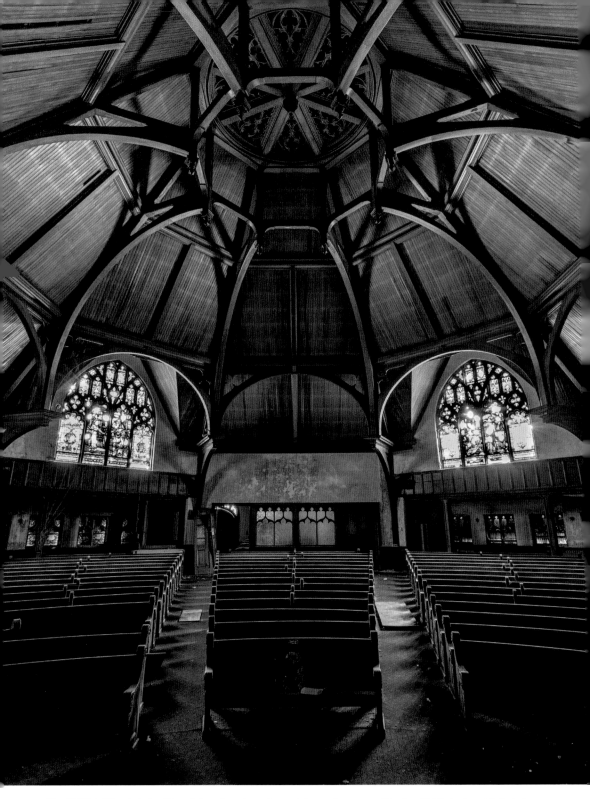

The Old Third Presbyterian Church has since been burned down after years of the local historical society trying to bring it back to life.

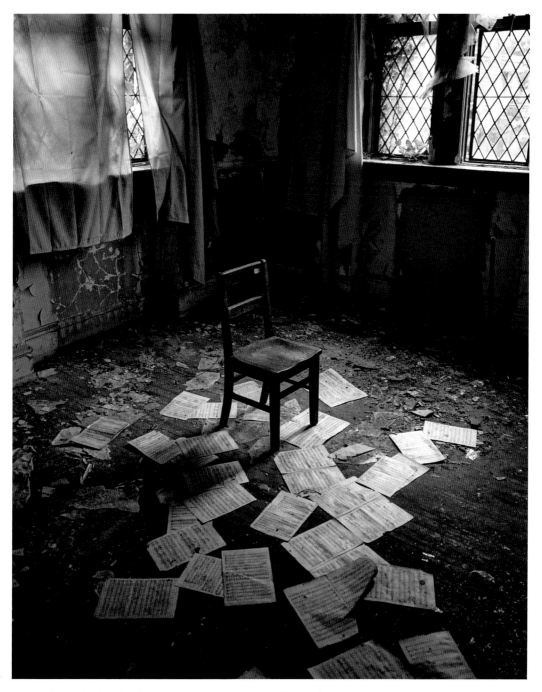

A chair left in a Sunday school classroom surrounded by sheet music.

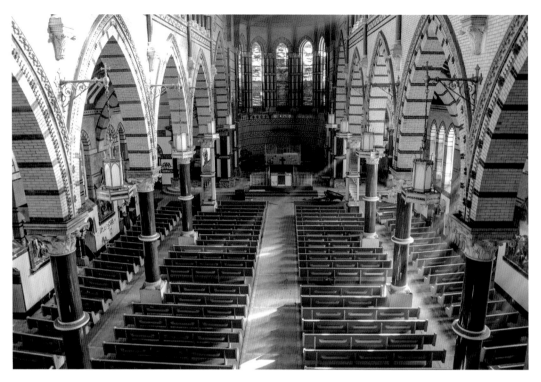

The very first abandoned church that I ever had the opportunity to photograph in Philadelphia.

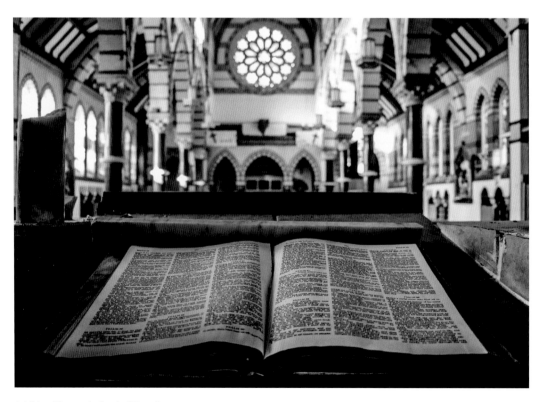

A bible still open in front of the altar.

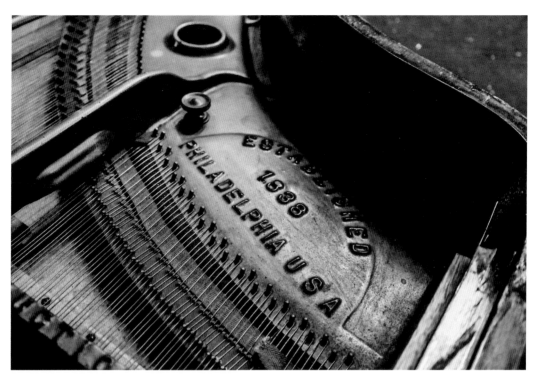

An old Philadelphia-made piano left inside the church.

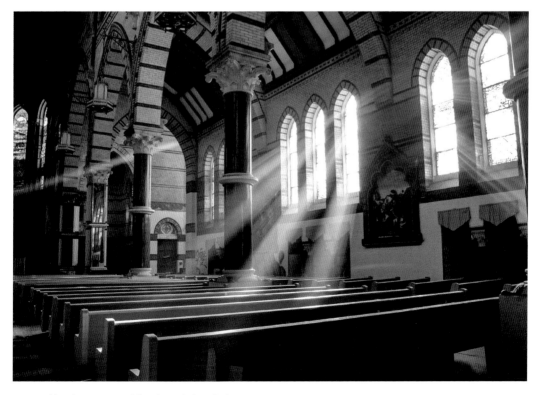

Morning sun rays shine through the windows.

# 5

# STATE HOSPITALS

W hile Philadelphia is not really known for its abandoned hospitals, there are two that lie outside of the city that have an interesting history to tell. Embreeville State Hospital, located in Chester County, originally started out as an almshouse in 1798. The facility cared for mentally ill patients and the less fortunate in the surrounding community. A century later, these facilities shifted their focus to providing care primarily for mentally ill patients throughout the commonwealth. The Embreeville campus grew over time, eventually becoming a semi-autonomous hospital. In 1938, after the establishment of the "Full State Care Act," Embreeville officially became a state hospital. The hospital was later cited by the American Psychiatric Association as one of three "model hospitals" in the country, with a 100 percent bed turnover each year.

In 1971, a portion of the hospital campus was converted into a juvenile detention center, and both hospital and detention operations were conducted simultaneously until 1979, when the hospital portion closed, which left only the detention center to operate until 1992. After the detention center closed, the campus buildings began to deteriorate, and by 2005, the entire property closed for good. Following the abandonment of the campus, years of vandalism ensued, leaving the facilities in ruins. Any chance of resurrecting this historical property became cost-prohibitive. In 2012, the 225-acre campus was sold to a developer. As of 2020, Embreeville has been slated for demolition and redevelopment as a business park.

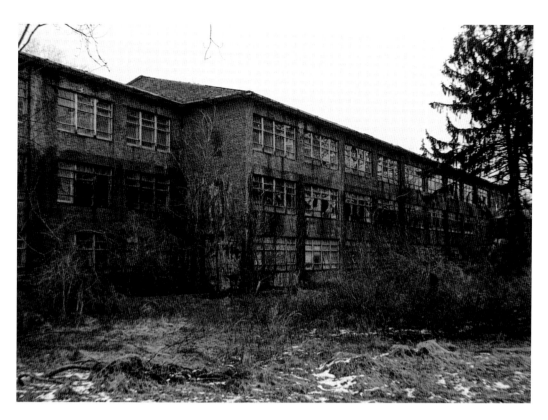

*Above:* One of the many buildings that made up Embreeville Asylum.

*Right:* A paint-peeled hallway.

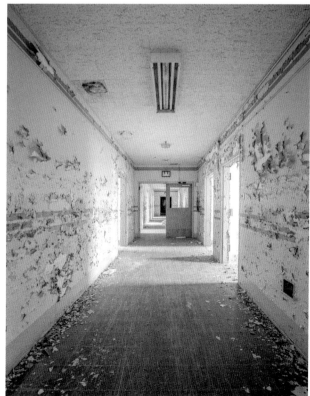

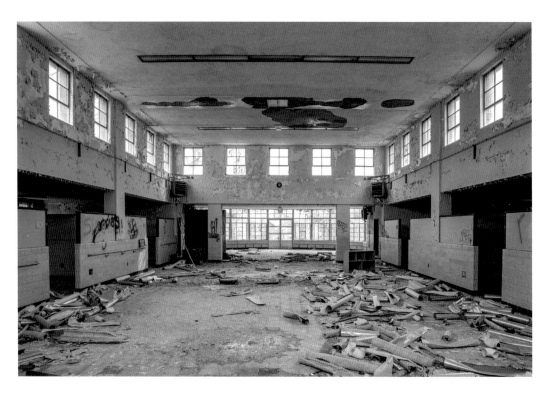

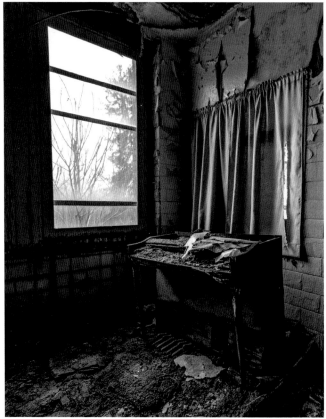

*Above:* Vandalism has been a major issue at this property as many teenagers come here just to mess around and destroy things.

*Left:* An old piano sitting in a corner, covered in a slowly crumbling ceiling.

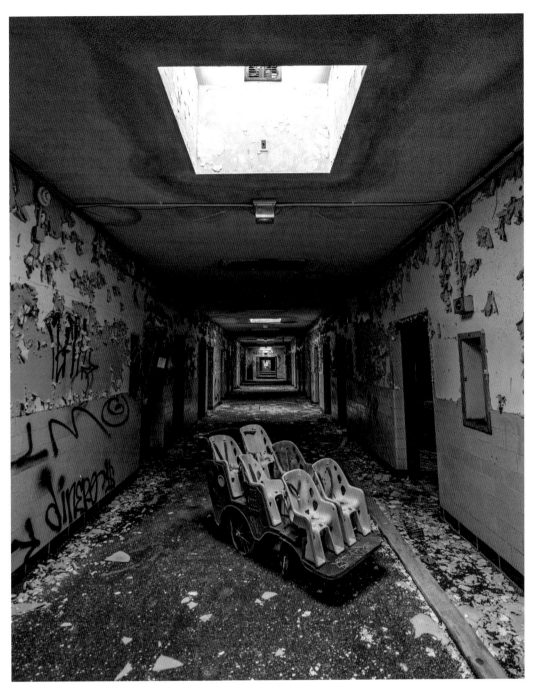

A "Bye Bye Buggy" that allowed workers to move children around the building more efficiently.

Norristown State Hospital was constructed in the late 1800s to alleviate overcrowding in psychiatric wards and other private hospitals in and around the Philadelphia area. In 1880, Dr. Alice Bennett became the first woman in the nation to direct a female division in a psychiatric institution by being appointed superintendent of the women's department at Norristown. In 1892, Norristown faced a backlash from the Board of Public Charities after two doctors, under the orders of Dr. Alice Bennett, were accused of human experimentation on six women after they removed their ovaries as a cure for insanity. The operation on these women was at first seen as a success, with three out of the six stating to have full recovery of both the body and mind. Later, this procedure was disproven as a viable cure. In addition to claims of human experimentation, Norristown also faced many cases of alleged abuse of patients.

Despite these occurrences, Norristown continued to grow and thrive well into the 1950s. Not only did the hospital care for mentally ill patients, but it also became home to two large tuberculosis treatment facilities. Over the next few decades, due to a push to end state-funded psychiatric centers, the population at Norristown declined, and the state was forced to shut down many of the buildings across the campus. Today, Norristown remains the only active state hospital in Southeastern Pennsylvania despite having many buildings around the property in a state of disrepair. I was lucky enough to gain special access to photograph one of the abandoned buildings on the property. I was awestruck by the variety of things left behind.

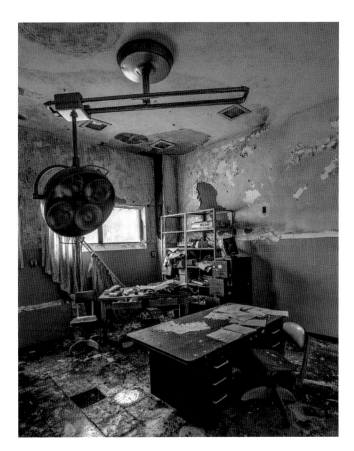

*Right:* An old surgical room turned into a doctor's office at Norristown state hospital.

*Below:* The dentist chairs and equipment left behind in one of the rooms.

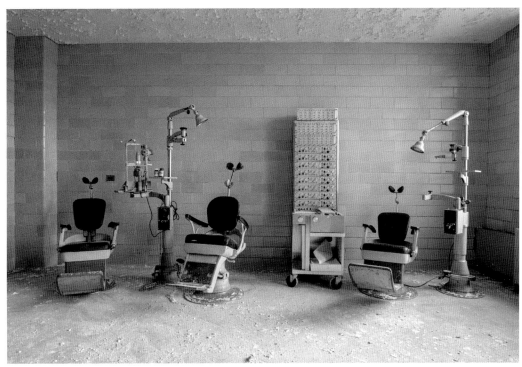

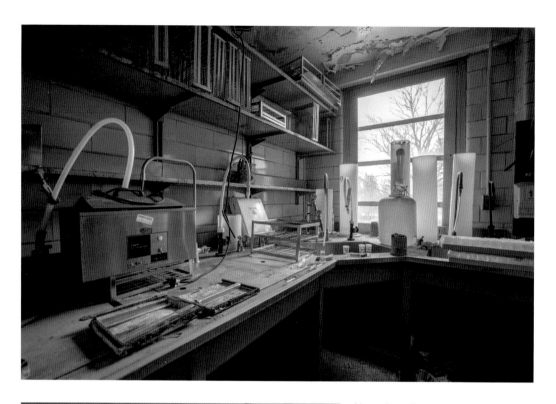

*Above:* A small sanitation room used to make sure equipment stayed clean.

*Left:* A piano left in the common area.

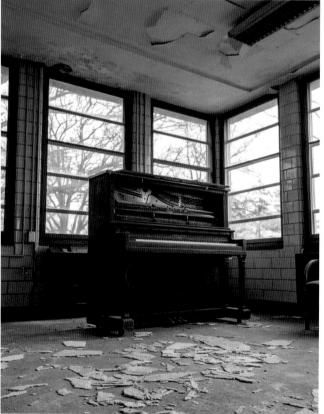

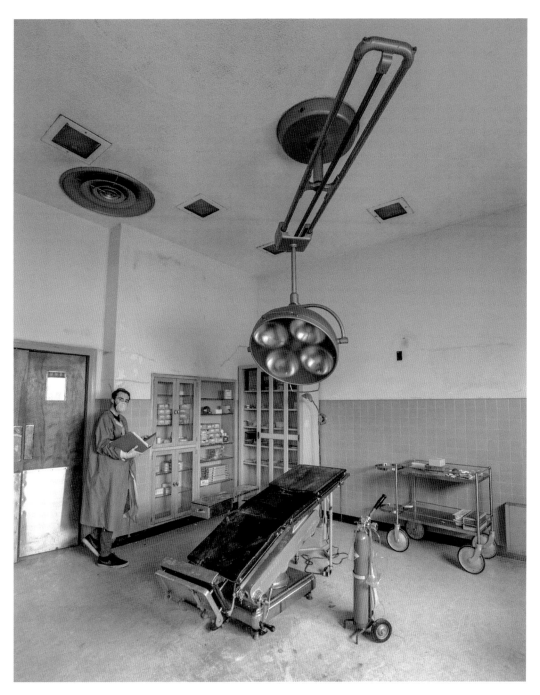

The doctor is in—a self-portrait inside one of the main surgical rooms.

# 6

# ODDITIES

I receive enjoyment out of exploring all types of abandoned spaces and discovering the story that each has to tell. Some of these unique environments do not really fit into one specific category, so here are a few other forgotten locations that I have photographed across the city of Philadelphia. You never know what you might find driving down a random street or going into what may just look like an old warehouse or building. We live in a society filled with substantial urban environments entirely built by people—environments that are continuing to age, and with age comes the responsibility to preserve or rebuild. Within the majority of my photographs, I aim to showcase not only the history these abandoned places have, but also the potential they hold for a second life.

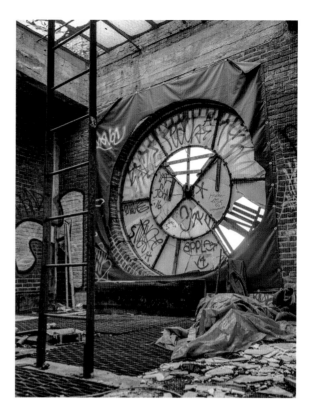

*Right:* A graffiti-covered clock tower that was part of an abandoned warehouse.

*Below:* An aerial view of graffiti pier.

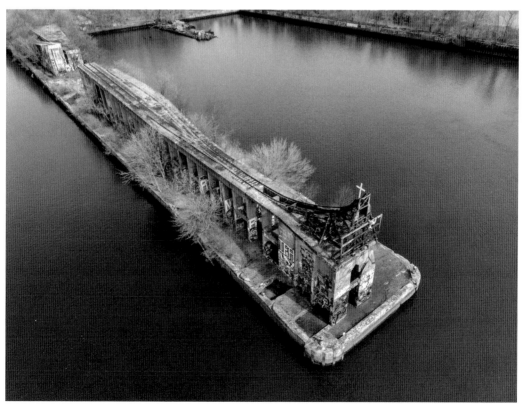

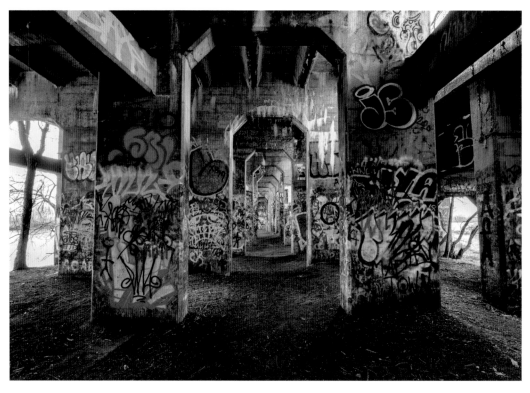

Covered in graffiti, the location gives an obvious reason for its namesake.

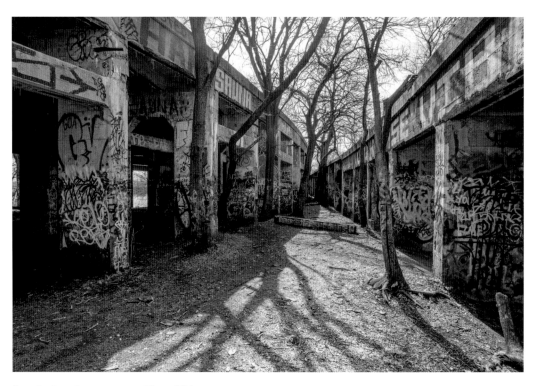

Even the trees become covered in graffiti tags.

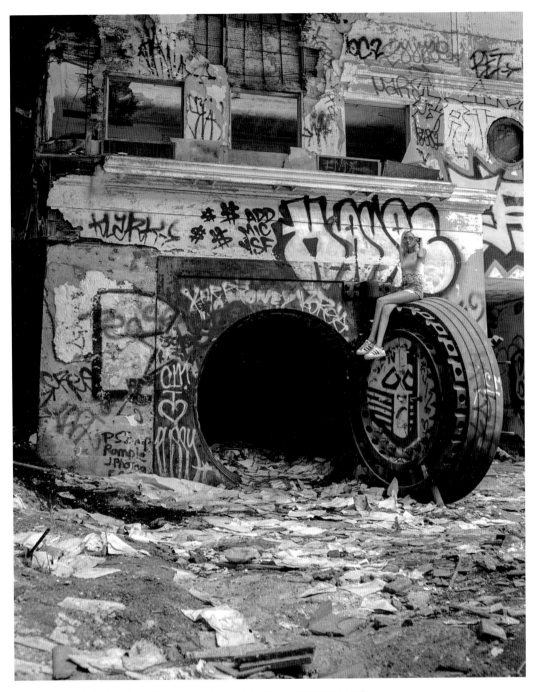

A friend of mine sits on top of a massive vault inside an abandoned bank.

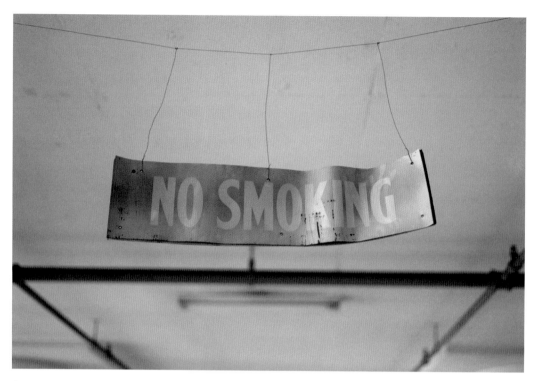

A no-smoking sign hanging above a hallway.

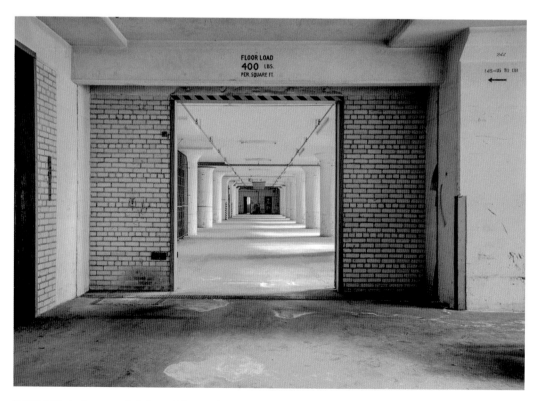

Looking down a long, empty hallway of the warehouse.

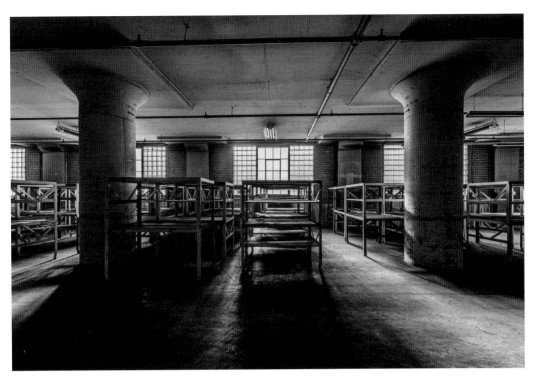

More empty shelves line another one of the floors.

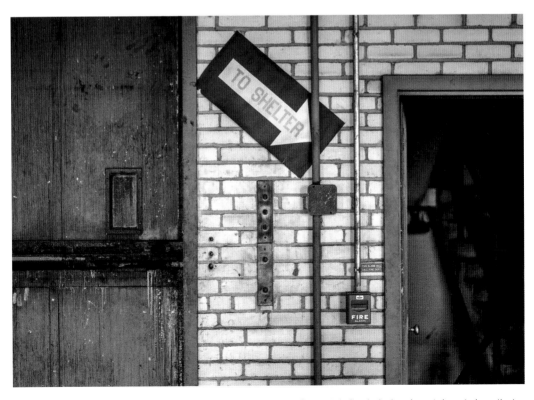

The building featured a nuclear fallout shelter that was unfortunately flooded when I went down to investigate.

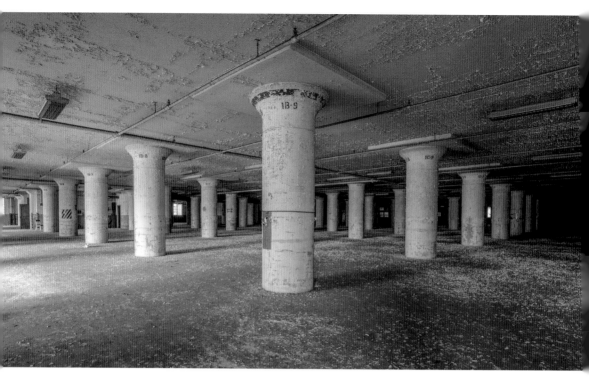

Huge concrete pillars support each floor to hold all of the extra storage weight.

YOUR
MOTHER
DOES NOT WORK HERE.

PLEASE PICK UP AFTER
YOURSELF.

218 NORTH 13th STREET
564-0164

A sign hanging outside of the men's locker rooms.

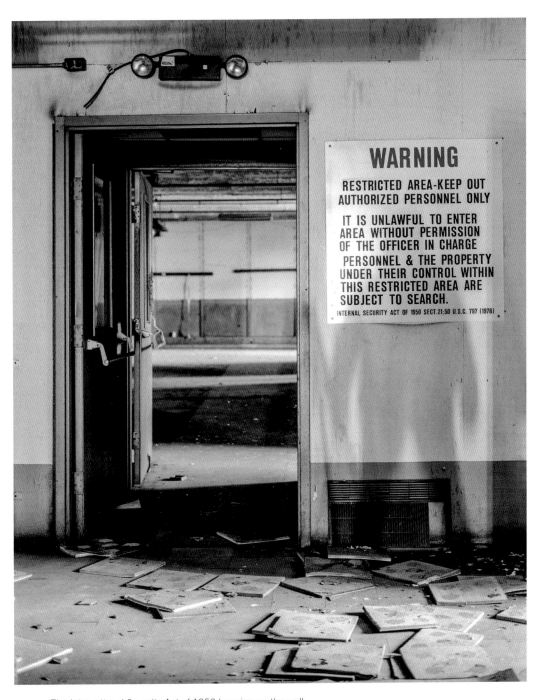

The International Security Act of 1950 hanging on the wall.

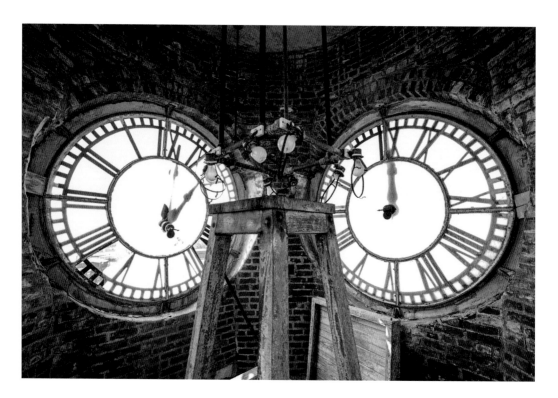

*Above:* Inside the clocktower of Germantown City Hall.

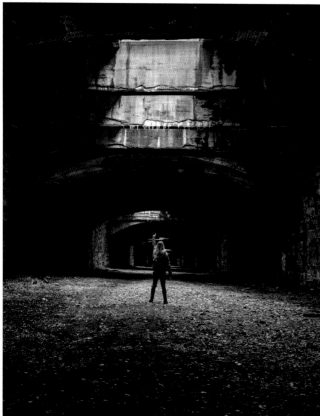

*Left:* The abandoned Reading Viaduct Tunnel is hidden beneath part of the city.

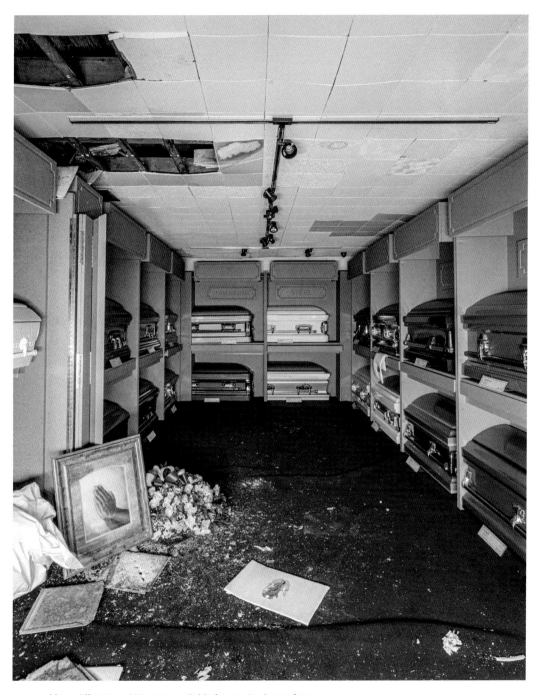

Many different caskets were available for one to choose from.

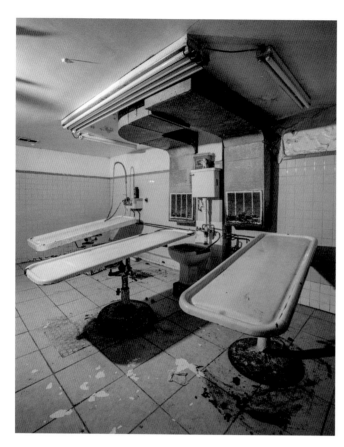

*Left:* The preparation room where bodies were made ready for the funeral, burial, or cremation.

*Below:* A Cadillac hearse still sitting in the garage after the businesses closed.

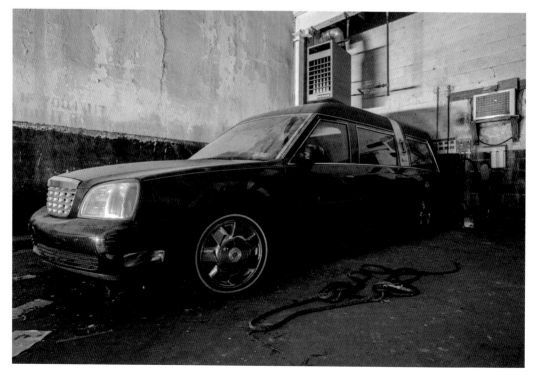

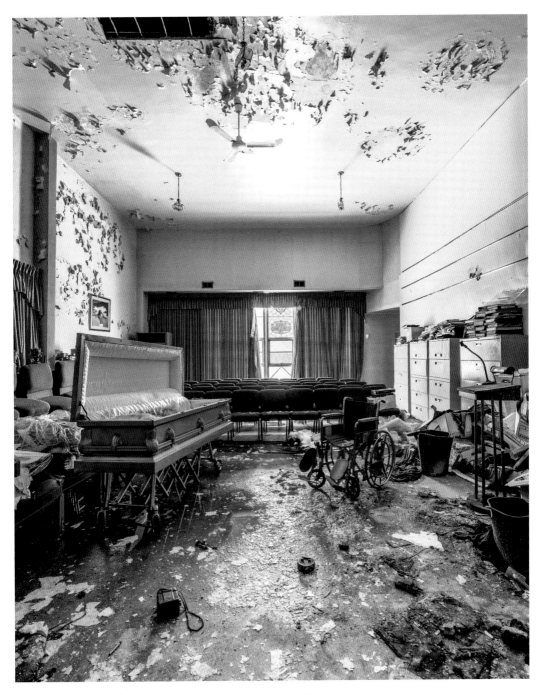

Another room where a casket sat open next to a wheelchair.

The Blue Horizon Boxing Ring was one of the last historic boxing venues to be open in Philadelphia. The ring hosted fights from the 1960s through to the early 2000s. At one point, this famous facility was featured in the movie *Rocky V.* The last fight at the Blue Horizon Boxing Ring took place in 2010 before the facility was closed due to a license violation. Eventually, the building was sold to developers, who have begun construction converting the building into a hotel.

At the age of seventeen, along with two of my friends, I headed to Philadelphia to explore several abandoned places, including this historic boxing ring. During the process of looking for a way in, we saw a phone number written in sharpie on the front door and decided to call it. To our surprise, someone answered and told us to wait outside, where he would come let us in. We waited around for a few minutes, then heard the shuffling of feet on the other side of the door. A man opened the door and told us to hurry in before anyone saw us. After giving us a look down, he introduced himself as Thomas. He told us that he was the caretaker, and we each needed to pay him $20 to take photos of the boxing ring, and that we only had thirty minutes to do so.

After paying our admission fee, Thomas led us through a maze of locked doors with old cans and other items strategically placed in a way to make noise if someone should enter the facility without his knowledge. Eventually, we arrived in the main part of the building. Thomas flipped a switch, revealing a red, white, and blue roped arena where so many great boxers once fought. After taking in this incredible sight, I decided to leave the lower level to explore the balcony above the ring. I came across an old, beaten American flag hanging along the banister that Thomas said was from the last fight held at the facility. The thirty minutes went by quickly, and we eventually had to say goodbye to the Blue Horizon Boxing Ring.

Once I heard the news that the building was being converted to a hotel, I made my return to visit Thomas three years later. There were construction workers all around the building when I arrived, and at first, I thought it might be too late. Much to my surprise, Thomas answered the door, but this time, things were different. Thomas had moved many of the old chairs in front of all the doorways. He had chained the entrances shut and installed multiple locks. Thomas was protecting the ring from the developers, trapping himself inside. You could hear the sadness and frustration within his voice.

I am not sure whatever came of Thomas, but I hope it is a better place than the old mattress he had set up in one of the offices of the boxing ring. To this day, many are not sure if he was the actual caretaker or not, but he cared for that place unlike any other. He was a true legend among the urban exploration community. I, along with many others, will forever be grateful for the efforts he made to try to preserve and save a truly iconic piece of Philadelphia's history.

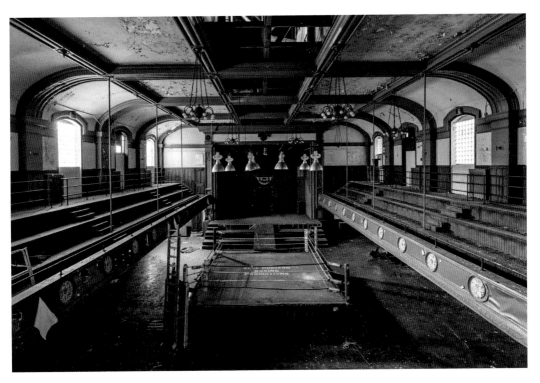

The Blue Horizon Boxing Ring, which held many notable events over the course of its lifetime.

Red, white, and blue ropes lined the historic boxing ring.

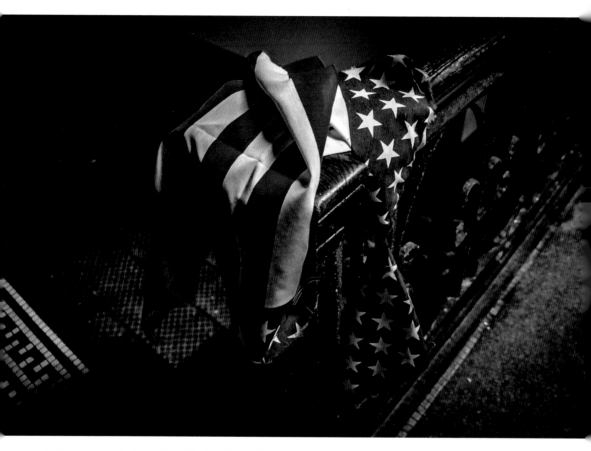

An American flag laying on top of the banister leading down to the boxing ring.

# BIBLIOGRAPHY

Blue Horizon, Philly Boxing History, from phillyboxinghistory.com/venues/venue_blue.htm

Cahal, S., 'Delaware Station of the Philadelphia Electric Company', Abandoned, from abandonedonline.net/location/delaware-station-of-the-philadelphia-electric-company/

Carlisle, D., 'In Search of The Girard', Hidden City, from hiddencityphila.org/2013/01/in-search-of-the-girard/, January 21, 2013

Embreeville State Hospital, Asylum Projects, from asylumprojects.org/index.php/Embreeville_State_Hospital

Goran, D., 'The abandoned Port Richmond power generation station stands out as an impressive monument to early 20th century industry', *The Vintage News*, from thevintagenews.com/2016/06/14/abandoned-port-richmond-power-generation-station-stands-impressive-monument-early-20th-century-industry/, June 14, 2016

Hildebrandt, R., 'New Life for Former Theater, Jazz Club', Hidden City, from hiddencityphila.org/2012/02/new-life-for-former-theater-jazz-club/, February 2, 2012

Jablon, P., 'Why All Philly Schools Look the Same', Hidden City, from hiddencityphila.org/2012/06/why-all-philly-schools-look-the-same/, June 29, 2012

Lambros, M., 'Logan Theatre—Philadelphia, PA', After the Final Curtain, from afterthefinalcurtain.net/2017/04/24/logan-theatre-philadelphia-pa/, April 24, 2017

Maule, B., 'Final Bell Nears at Brutalist Southwest Philly Middle School', Hidden City, from hiddencityphila.org/2013/04/final-bell-nears-at-brutalist-southwest-philly-middle-school/, April 17, 2013

Norristown State Hospital, Asylum Projects, from asylumprojects.org/index.php/Norristown_State_Hospital

Quirk, G., 'Benn Theatre', Cinema Treasures, from cinematreasures.org/theaters/3957

Quirk, G., 'Uptown Theatre', *Cinema Treasures*, from cinematreasures.org/theaters/1807

Romero, M., 'The current state of Philly's churches and sacred spaces, in five charts', Philadelphia Curbed, from philly.curbed.com/2017/10/19/16499480/ philadelphia-churches-adaptive-reuse-pew-report, October 19, 2017

Whalen, J., 'Germantown: The History and Aftermath of Germantown High School', *Philadelphia Neighborhoods*, from philadelphianeighborhoods.com/2015/05/04/ germantown-the-history-and-aftermath-of-germantown-high-school/, May 4, 2015

# ABOUT THE AUTHOR

**CHRISTOPHER HALL** is currently a student at the Maryland Institute College of Arts, working towards a BFA in photography. At the young age of twenty-one, he has received a variety of awards for his work and has been featured in a variety of galleries and publications. Christopher began exploring abandoned places about four years ago, and it has been a very strong passion of his ever since. Based in Baltimore, Maryland, he travels all over the United States exploring what has been left behind in hopes to shed light on the history and story the places have to tell. More of his work can be found on his Instagram page @hallchris and his website www.hallchrisphotography.com.

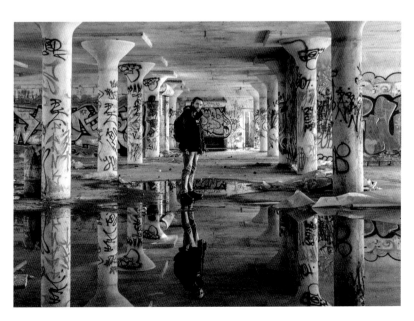